STUDIO VISTA

Drawing Basics

PATRICIA MONAHAN

STUDIO
VISTA

ACKNOWLEDGEMENTS

The author and publisher would like to thank the following artists who
have allowed us to use their work in this book: Gordon Bennett, pp. 10, 77;
Sarah Cawkwell, pp. 6–7; Pippa Howes, pp. 16–17; John Lidzey, pp. 4–5;
Stan Smith, p. 8; Bill Taylor, pp. 11, 77; Brian Williams, p. 9;
Albany Wiseman, pp. 11, 13, 20–21, 48–49, 63, 66–67, 78–79;
Annie Wood, p. 35.

Special thanks are due to Albany Wiseman for the step-by-step
demonstrations and artwork, to Rexel Limited for allowing us to
photograph in their factory and to Fred Munden for taking the photographs.

Studio Vista
a Cassell imprint
Wellington House
125 Strand
London WC2R 0BB

First published 1995

British Library Cataloguing-in-Publication Data
A catalogue record for this book is available from the British
Library.

ISBN 0–289–80122–2

Series editors: Jenny Rodwell and Patricia Monahan
The moral rights of the authors have been asserted

Distributed in the United States by
Sterling Publishing Co. Inc.
387 Park Avenue South, New York, NY 10016–8810

Typeset in Great Britain by Litho Link Ltd.
Printed in Great Britain by Bath Colour Books Ltd

CONTENTS

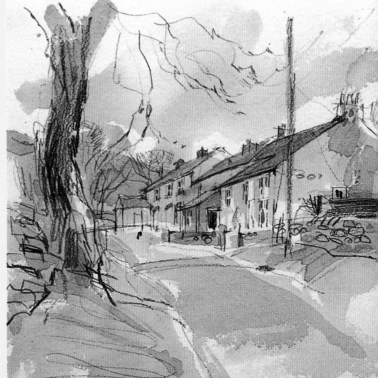

Introduction

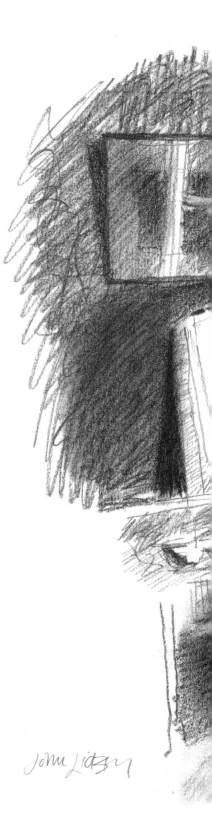

D RAWING CAN BE many things but here I am concerned with 'objective' drawing, that is, drawing which is intended to represent what is seen. This sort of drawing is based on close observation and interpretation of the world about us. Drawing in this analytical, enquiring way allows us to discover and describe the appearance of things. We learn how to create an illusion on a two-dimensional support.

For most artists it is the foundation of all their work.

In this book I explain some basic principles and suggest exercises to improve your powers of observation and your ability to record accurately what you see. Some of these are illustrated with step-by-step projects. Set up similar subjects of your own rather than copy what the artist has done – you will learn more by working from life and making your own mistakes.

And remember that it is the process that is important, not the end product. Your drawings are like a pianist's finger exercises or a dancer's work at the barre. You may end up with some fine drawings which you want to frame and admire but that is incidental. It is your increased facility and understanding which is the goal.

John Lidzey

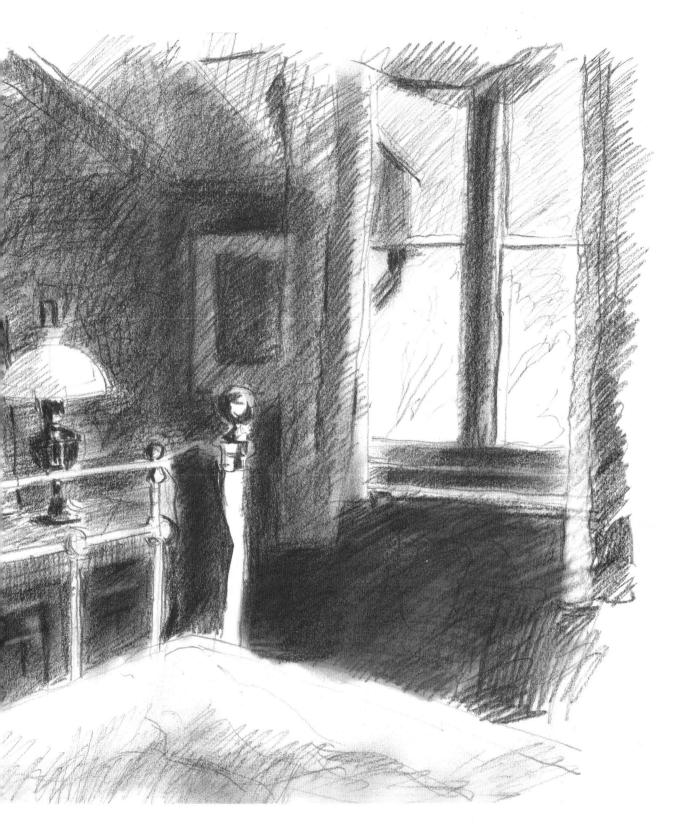

'The Dell — visitor's bedroom'. This intensely
atmospheric drawing is by John Lidzey, an artist who
often makes the quality of light in an interior the subject
of his work. Natural light filters into the bedroom,
highlighting some areas, throwing others into shadow.

DRAWING IS FUN

Drawing is the most natural occupation imaginable – give a young child a pencil, a piece of chalk, even a stick and it will begin to make scribbled marks. Unfortunately, this natural inclination is often curtailed at an early age. A critical, joking or sarcastic comment by a teacher or parent undermines our confidence and drawing becomes a chore rather than a spontaneous means of expression. Our enjoyment of the process is spoiled by the conviction that the end product is not good enough and therefore not worthwhile.

Does this sound familiar? If it does, you should start by reclaiming the pleasure you had in drawing as a child. Try and recall the joy of opening a new box of crayons with their special waxy smell and shiny fruit-bright colours.

Before you start doing some serious drawing spend time playing with whatever drawing materials you have. Settle down somewhere comfortable with a piece of paper and a favourite drawing implement – a sharp pencil, some coloured crayons or a dip pen and good black ink. If you find music relaxing, have some playing in the background. Now focus on the paper and, holding your pen or pencil fairly loosely, allow the pen to wander over the paper – a process the Swiss painter Paul Klee (1879–1940) called taking your line for a walk. After a while, stop. Focus on the marks you have made and see if they suggest an image or the next mark you should make.

Soon you will be completely absorbed, making more lines, adding swirls and curls, filling in one area and finding trees or clouds emerging in another. Don't force your drawing and don't judge what you are doing. Simply enjoy the experience. This is a marvellous way of freeing up and getting to know and feel comfortable with your drawing implement. It also gives you an intimation of the sense of involvement and discovery which makes drawing so immensely enjoyable.

In this book I hope to give you a kick-start – to

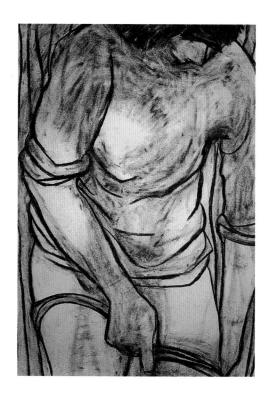

△▽ *'Dressing, 1985', above and 'Hairpiece, 1994', below, charcoal, by Sarah Cawkwell. The artist has taken everyday subjects and by close observation, meticulous description and clever composition has created images which are vigorous, bold and intensely moving.*

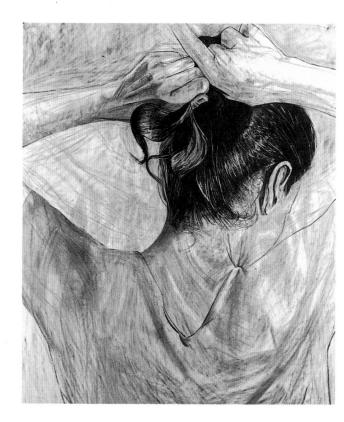

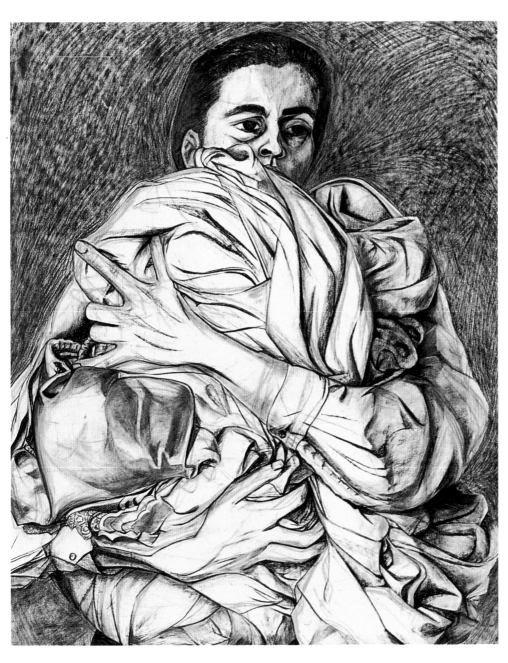

◁ *In 'For the white wash, 1994' the artist, Sarah Cawkwell, has taken a fairly unpromising subject and turned it into a compelling image. Her acutely detailed exploration of the texture and complex forms of the crumpled linen has a certain unwavering quality which makes us see a mundane subject as fascinating and beautiful. She fully exploits the linear and tonal qualities of charcoal to create an image which is descriptive, lyrical and decorative.*

get you drawing if you haven't tried before and to brush up existing skills if you have. The basic skills provide a solid foundation but you must also learn to express yourself and develop a drawing style which reflects your personality, your intention and the subject you are dealing with. Experiment with different subjects, approaches, and materials.

The best way of increasing your understanding of drawing and its possibilities is to study the work of other artists, particularly the masters like Leonardo da Vinci (1452–1519), Albrecht Dürer (1471–1528) and Pablo Picasso (1881–1973). Their works are frequently reproduced in books, and most museums and art galleries have collections of drawings. Often these are not on display but can be viewed on request.

You'll soon find that the range of materials, styles, subjects and approaches is almost infinite. Drawings can be restrained, cool and clinical or bold, violent and aggressive. They may be the work of many hours close observation or of mere seconds – an instant impression. Some are a flurry of expressive line and tone which is almost abstract – you may not be sure what the subject is but you have a jolly good idea how the artist felt about it as he transferred his impression to the paper.

IMPROVING YOUR SKILLS

Drawing is a challenge. It isn't easy – but everyone can improve their drawing skills. There are no short cuts – the only way of getting better is to draw as often as you can. Experienced artists draw all the time. It is a way of keeping their eyes alert, their minds fresh and their fingers nimble.

So set yourself tasks. The most important thing is to make drawing an integral part of your life, something you do every day even if it is only a scribbled sketch which takes seconds. Look at your routine and decide where drawing slots in most naturally. Perhaps you could use your lunchbreak to make some quick notes in the park? Do you slump in front of the television in the evening? Then leave a sketchbook and drawing materials in the room and make a habit of drawing something every day. Your subject can be anything – a member of the family, the vase of flowers on the coffee table, the view from the window, the cat or the dog, or a corner of the room. It really doesn't matter what it is or how often you draw it. You will learn something each time and your drawing will become more accurate and accomplished. In a matter of weeks you will be astonished at your progress – and when you look back in a few years' time you will be delighted with both your progress and with the record of your daily life.

Television can provide useful practice in drawing moving subjects – the images change quickly so you are forced to concentrate and use your memory. Work fast, concentrate on the subject and don't look at the drawing until you are finished. At first you will produce a mass of unintelligible squiggles but as your memory, concentration and eye to hand co-ordination improve you will begin to describe what you see with great economy and character.

You should also set aside some time each week for 'serious drawing'. You could devote this time to doing some of the exercises described in this book. These sessions should be rigorous: the more you put in and the more severe you are with yourself, the more value you will get from them.

People vary in the way they work. Some are happy to work on their own and need no other motivation. Others need companions to encourage them. If you fall into the latter group persuade a friend to work with you once a week, or join a local drawing class. Some of these are quite formal with structured tuition; others are simply groups of people who get together and share the cost of studio hire and, perhaps, a model. If you want information, perhaps your first port of call should be the local library. The reference librarian will be able to point you towards information about local classes. Another source of information is an art supplier.

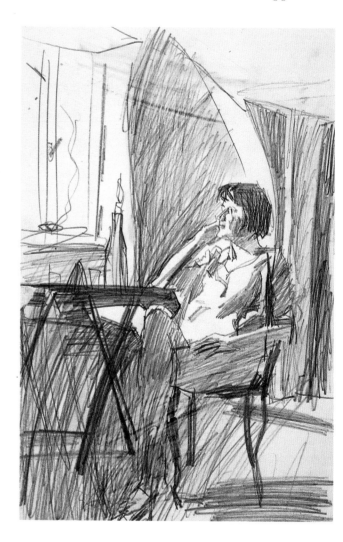

△ *'Girl seated by a window' by Stan Smith. The artist was fascinated by the way the light from the window splashed across the female form, creating areas of brightness on her face, torso and forearm while other areas were in deep shadow. It is really a drawing of light, acutely observed but scribbled down in moments.*

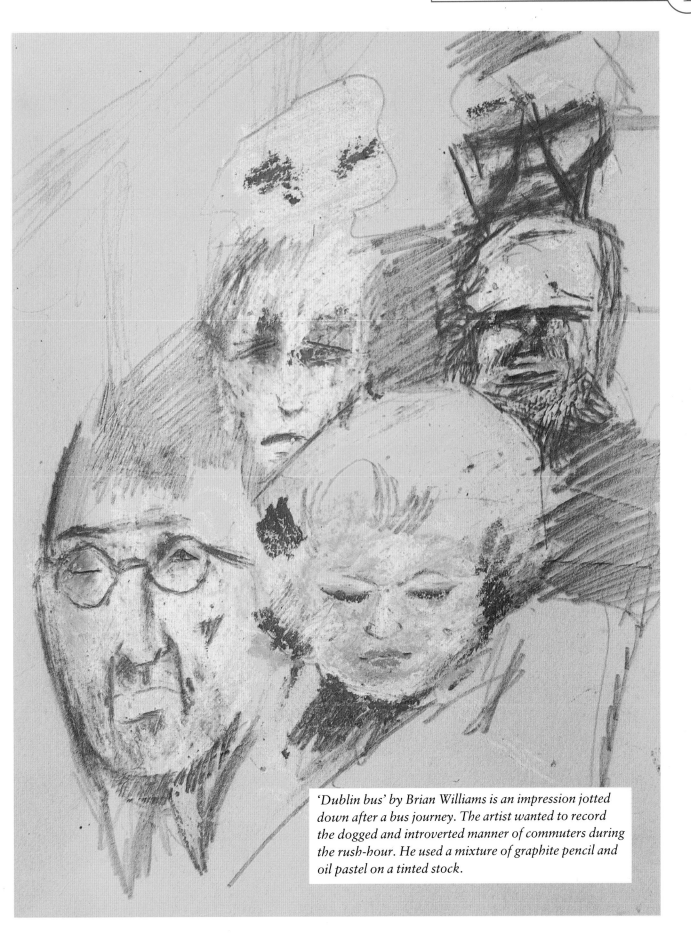

'Dublin bus' by Brian Williams is an impression jotted down after a bus journey. The artist wanted to record the dogged and introverted manner of commuters during the rush-hour. He used a mixture of graphite pencil and oil pastel on a tinted stock.

THREE DON'TS

There are three attitudes which can impede your progress: timidity; over-confidence; and laziness.

Don't be tentative. If you are, you will avoid projects which you consider difficult ... 'Oh, I can't do hands' or 'I simply cannot do portraits' you'll say – and if you don't you won't. Nothing is ever as difficult as you think. So don't limit yourself, but have a go at everything. In many ways one subject is much the same as another – so start by forgetting that what you are looking at is a table, a chair, a cat or a person and simply treat it as a jigsaw of patches of light and dark, shapes and outlines – an abstract form.

Be bold and experiment with materials. If you come across a new drawing implement, try it out. Although you can do quite well with nothing more than a pencil, it is a good idea to change your medium from time to time. A new medium confronts you with new problems and it is by overcoming problems that you make progress. If you are too careful you will miss exciting new experiences and challenges.

Don't be over-confident. If you over-value your achievements you won't strive to improve. It is often the individual who has been fêted through school as a 'good drawer' who stultifies and makes no progress. Subject your work to constructive criticism: decide what works and what doesn't, so that you can overcome your weak points.

And finally, don't be lazy. Lack of application is a pitfall for the beginner, especially if there is no-one to push you. Drawing is fun – but I didn't say it was easy. Without constant struggle work gets tired and repetitive. Treat every drawing as a new challenge. Even the work of the most accomplished artist will look hackneyed if it lacks a sense of discovery, of boundaries being tested. For a true artist every drawing is an exploration. And try not to develop systems for handling particular subjects – these very quickly become clichés. The exercises in this book can be usefully repeated many times with different subjects.

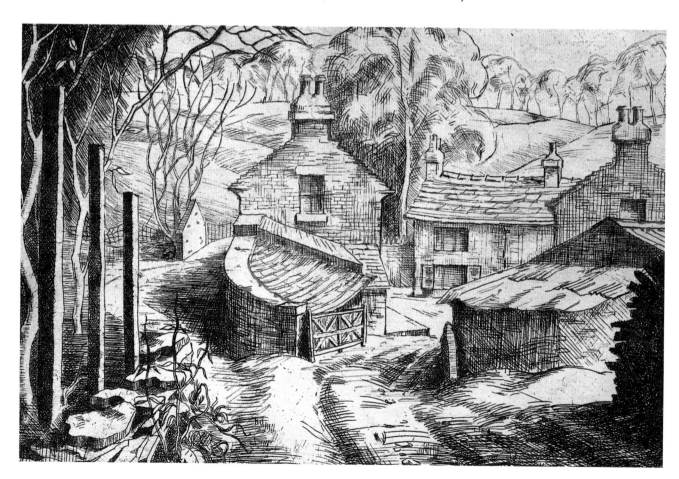

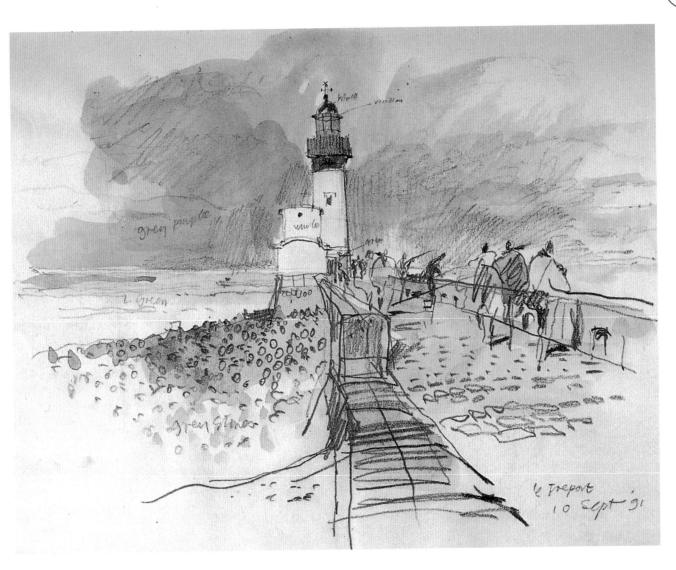

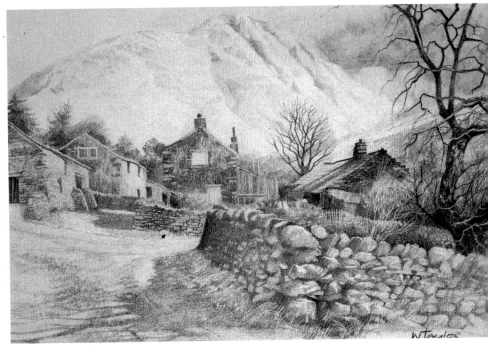

△ *The study of a lighthouse is by Albany Wiseman. Washes of colour and notes were useful information for the painting he made later.*

◁ *'Farmyard' by Gordon Bennet. There are many ways of tackling a particular subject. For this drawing the artist used a fine-liner fibre-tipped pen and an orderly system of hatching and cross-hatching.*

▷ *This landscape drawing is by Bill Taylor. Pencil and colour pencil were combined to create an image which is detailed yet also atmospheric.*

Getting started

●

*T*HERE ARE THREE main ways of drawing: line, tone and rendering. Line drawings are the most succinct and in many ways the most abstract. When a line drawing comes off it has the economy and clarity of vision of the best poetry. The quality of the line can be as revealing as handwriting – line can be crisp and direct, dark and bold, expressive, impersonal, energetic, wayward, aggressive or even neurotic.

Tonal drawings describe forms by exploiting light and dark and the grades in between – in the same way as black and white photography does. In a tonal drawing gradations of tone are achieved by blending so that one tone grades imperceptibly into the next. Soft media such as chalk, charcoal and graphite powder lend themselves to this sort of drawing, but soft pencil and pastel can also be used.

Another way of achieving an illusion of form is by rendering tone by methods such as hatching, cross-hatching and stippling. These may be rigorously mechanical or loosely applied using scribbled marks. A drawing may incorporate several techniques.

●

▷ *A selection of drawings by Albany Wiseman suggest the richness and excitement that drawing offers. These are records of people and places, as well as exercises in composition, colour and mood and are a source of inspiration to which he constantly returns.*

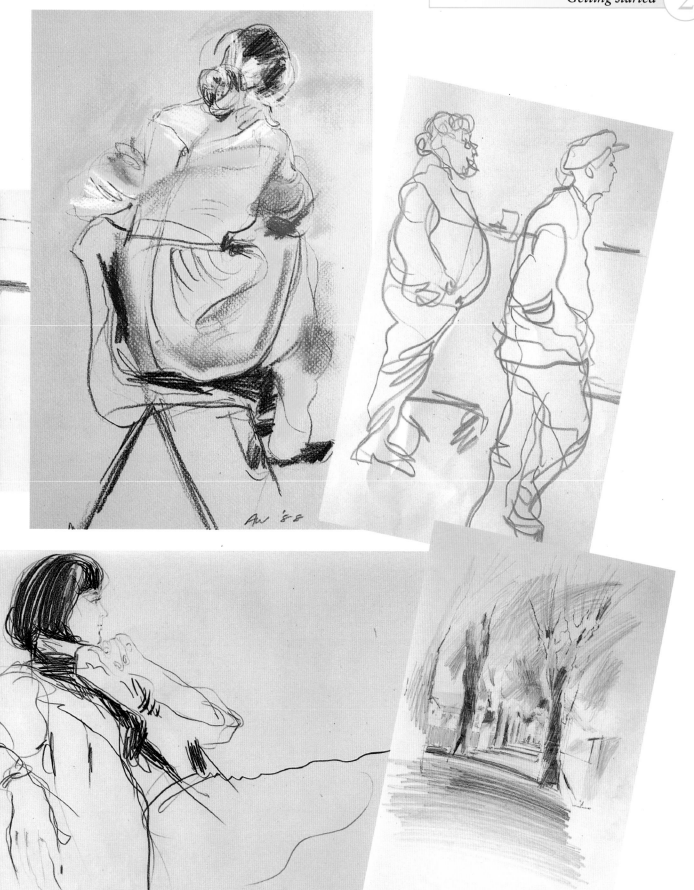

PENCILS AND THINGS . . .

The pencil was probably the first drawing tool you used as a child and it is undoubtedly the basic drawing tool of the artist. Perhaps you've never thought about the pencils you use, but you may have noticed that some pencils give you a pale grey line and are so hard they cause indentations or even tear flimsy paper. Other pencils are softer, darker and are so smeary that you get into quite a smudgy mess with black graphite on your hands and all over the paper.

The term 'lead pencil' is misleading for pencils no longer contain lead. Thin rods of metallic lead were used as pencils in the ancient world, but these days pencils are made from graphite and clay.

Pure graphite was used as a drawing material when graphite deposits were discovered at Borrow-

dale in Cumberland in the sixteenth century. The monopoly for this material was held by the Crown, and Borrowdale supplied Europe until supplies ran out 300 years later.

Graphite was used in a solid lump or in a holder. Because the natural material was scarce and costly there was a search for a replacement material.

T & H Rowney began to manufacture graphite sticks encased in wood in England in 1789. Napoleon commissioned the inventor Nicholas-Jacques Conté to find a substitute for natural graphite. In 1795 Conté patented his process which was the forerunner of the modérn pencil. He used a paste of clay and graphite powder which was pressed into grooves in cedar wood. The advantage of these pencils was that they could be graded for strength and tone.

Artists' pencils are graded in twenty grades of hardness using a system based on letters: BB, B, F, HB, H and ranging from 8B, the softest, to 10H, the hardest. One manufacturer's 6B may be equivalent to another's 4B, and few manufacturers offer the entire range.

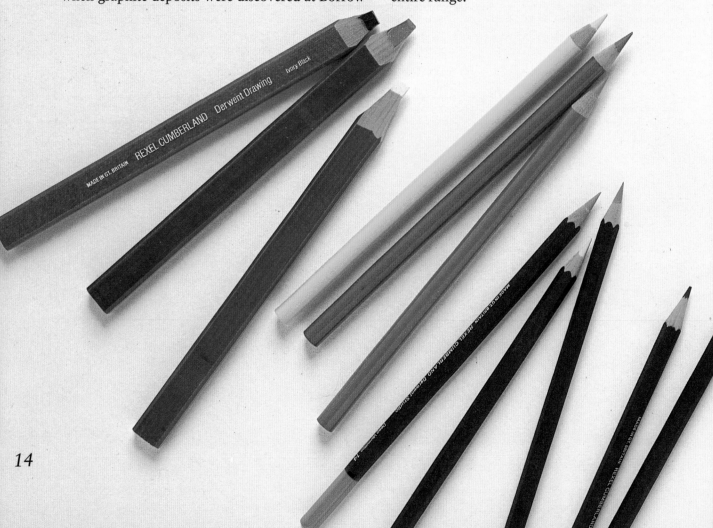

Charcoal

This is probably the next most important drawing medium. It is a naturally expressive and spontaneous medium with a wonderfully black velvety quality. Probably the oldest drawing medium known to man, it is available in several forms: natural willow or vine charcoal in various thicknesses; compressed charcoal sticks; and charcoal pencils, which are harder than other forms.

Soft pastel

Soft pastels are pigments bound with gum or resin and available in stick form. They are usually round in section though some are square and they vary in degrees of hardness, depending on the amount of binder and chalk used in their make-up. In time you will become familiar with the products of different manufacturers, but it is worth experimenting until you find the product that suits you best. Because pastel is so soft and crumbly, most pastel works need to be fixed with a spray fixative although fixing does flatten colour. Nevertheless pastel colours are wonderfully intense. Pastel is also available in pencil form. These are harder and, because they can be sharpened to a point, are ideal for detailed work.

Coloured pencils

There is a wide range of coloured pencils on the market. The most traditional are fairly hard and waxy, but softer blendable pencils are now available. These are particularly pleasing to use and can be smudged with the finger or blended with a little turps or solvent in order to create a more tonal composition. Watersoluble pencils can be blended with water and combined with watercolour washes to very good effect.

A selection of drawing materials, from left to right: flat 'carpenter's' pencils; several brands of coloured pencils; willow charcoal; water-soluble crayons; soft pastels; graphite stick; a stump, torchon or tortillon; soft pastels.

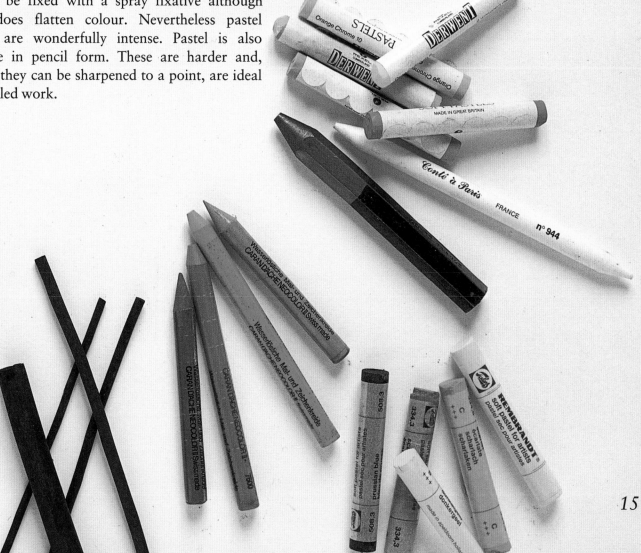

Fountain pens have a reservoir of ink, either as a replaceable cartridge or a refillable pump-action reservoir. They are useful for sketching away from home as you don't have to carry a bottle of ink with you.

Quill has a tough, rather scratchy quality and a characterful line. Other traditional pens include reed and bamboo.

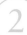

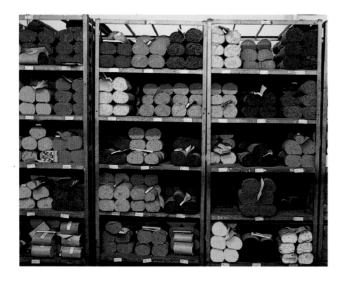

△ *The 'leads' of coloured pencils stored in racks at the Rexel factory.*

▷ *'Vegetable still-life' by Pippa Howes. This vivid drawing is built up using layers of carefully applied coloured pencil. It is a simple, everyday subject, but the artist has captured the vibrant colours and luscious textures of the vegetables and created a dramatic image. Vegetables, with their wonderful shapes, textures and colours make fascinating subjects for the artist.*

Markers and fibre-tipped pens

The chisel tipped marker was originally a graphic designers' tool. It is available in an extensive range of colours and in a watersoluble or spirit-based form. In recent years manufacturers have developed a bewildering range of related products. Some are spirit-based, others are watersoluble. Some are available in a limited range of colours and are intended as a writing or drawing tool. They are good for sketching – choose between the solid black line of a fibre tip or the delicate line of a fineliner. Another interesting development is the brushpen. It has a flexible fibre tip which resembles the quality of a brush. The disadvantage of markers is their tendency to fade if exposed to light.

Pens

Pen and ink is a very pleasing medium. By twisting the nib of the pen and varying the pressure you can create a thick or thin line. You can work with outline or create tone using hatching and stippling techniques. The range is tremendous. The simplest are dip pens. Brushpens have two metal plates and hold a lot of ink and create bold, broad lines. Mapping pens have very fine nibs suitable for technical work. Script pens are available in a range of nibs – some fine and pointed, others rounded and some chiselled for italic lettering. They are cheap and you might decide to have a variety for different purposes.

Inks

Here too there are choices to be made. Indian ink is black and dries to a waterproof film. Coloured inks are transparent and have a jewel-like brilliance. Most are dye-based and therefore fugitive – they fade on exposure to light. They are most suitable for illustrations for printed reproduction in which case it doesn't matter if the original loses its initial brightness. Similar to coloured inks are the brilliant watercolours. These too are dye-based and fugitive, but they dry to a soluble film. New, and in many ways more satisfactory, are the liquid acrylics which are pigment-based and bound in an acrylic medium. They dry to a permanent film and are light-fast so that they will not fade over a period of time. There are many different ranges on the market – some are transparent like traditional inks while some are opaque, like a very fluid paint film.

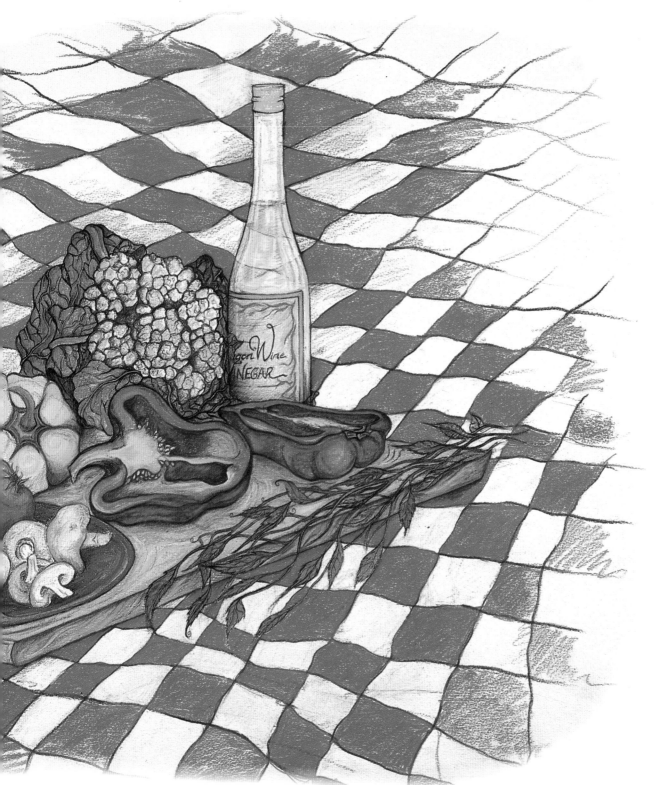

PAPERS AND SKETCHBOOKS

There are a bewildering range of drawing papers on the market. In the space available I can't hope to describe them all, but I will try to explain some of the categories and terminology so that you can understand the description in the art shop and know what you are looking at. And if you have a particular requirement do ask the assistant in the art shop – they are usually very informed and eager to help.

Paper is made from a pulp of cellulose fibres and water. The cellulose may be wood, cotton or linen. Cheap papers like newsprint are made by pulping all the wood. The fibre is acid and the paper deteriorates and yellows quickly. You will come across the term 'woodfree' paper. This doesn't mean there is no wood in the recipe – it means that it is made from a chemical woodpulp in which the fibres have been separated from the lignin which is the acidic, destructive component – really it should say lignin-free. Most artists' papers are made from a combination of woodfree fibre and cotton. The very best papers are 100% cotton. The cotton is derived directly from the cotton plant (cotton linter) – though the fibre used to be derived from recycled cotton – hence the term 'rag' for paper which contains cotton. Cotton is strong and non-acidic.

Paper weights
Papers vary in thickness and density, which is expressed as weight per ream (500 sheets) or grammes per square metre. If you are going to lay a

The range of papers available is daunting. Here we show a range of drawing, pastel and watercolour papers available as pads and single sheets. Some cartridge and watercolour papers are also available on the roll.

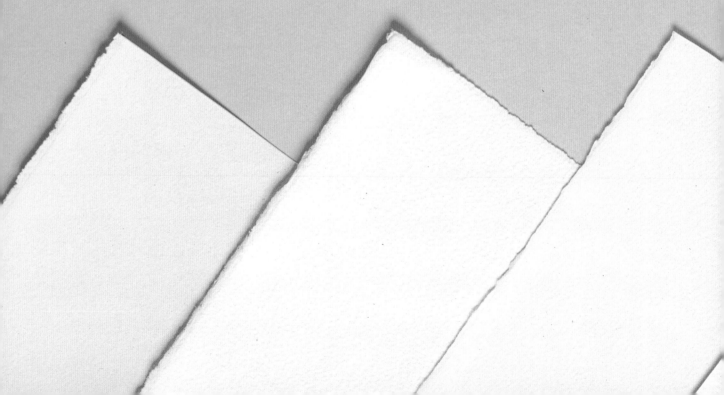

wash over a drawing you will need to stretch the paper or choose one of about 140lb (300gsm) — otherwise the paper will stretch when wet, causing it to cockle.

Paper surface

Hot pressed (HP) paper has a smooth surface created by passing it through heated rollers in the paper mill.

NOT or cold pressed paper has a rougher surface. It is passed through cold rollers so it is 'NOT' hot-pressed.

Rough paper has the most textured surface. It carries the imprint of the blankets which the partly formed sheet is pressed between.

These surfaces are relative — one manufacturer's rough is another's smooth.

Sizing

Unsized paper is very absorbent like blotting paper. For any technique which employs a wash you will need a sized paper. Size is a seal or glue which is applied to the paper to render it less absorbent and prevent inks and water going into the paper. Sometimes size is added to the paper pulp to seal the pores (engine sizing). Other papers are surface sized. Starch is used to smooth the fibres and improve the paper surface. Gelatin (tub sizing) makes the surface smoother and resilient so it can withstand abrasion.

Production methods

Paper is made in three ways. Handmade papers are the most stable, hard-wearing and long-lasting. They are also the most expensive. The wood pulp is laid onto a wire mesh and vibrated so that the water drains through. The fibres mesh randomly so that the paper has strength in all directions. A sheet of handmade paper has a characteristic frilly deckle edge on all four sides. The sheets are generally loft dried slowly. Handmade papers have a range of wonderful surfaces which are a pleasure to use — but they are costly.

Mould-made paper is made on a board or

cylinder mould machine. The process is slow and it is possible to make strong, bulky papers. The fibres are more haphazardly orientated than with paper made on a conventional industrial machine. Mould-made paper has two deckle edges formed where the paper pulp meets the two edges of the cylinder. The term 'mould-made' tells you that the paper falls between handmade and machine-made paper in terms of strength and character.

a distinctly ribbed appearance. All handmade or mould-made paper has a laid appearance created by the mesh of wires laid at right angles to one another. In machine-made paper the laid appearance is embossed on to the paper.

Watermarks

These are trade names embossed into the paper – you can see them when you hold the paper up to the

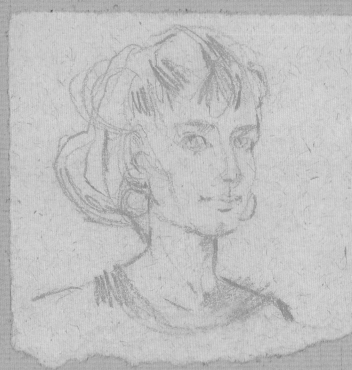

△ *A drawing on textured gunny paper, in earth red pencil, using fine, delicate lines for the nose, facial details and some of the hair. Thick, bold lines define shadowed areas with vigorous, scribbled hatching for areas of dark tone.*

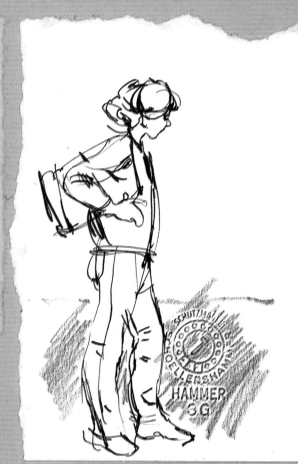

△ *Using pen and ink on the very hard-surfaced Schoellershammer paper creates an entirely different quality of line. The pen's very hard Myers crow-quill nib achieves a wonderfully fluent line. Thick, soft pencil scribbles in an area of dark tone.*

Machine-made paper, made on the Fourdrinier machine, is the cheapest. The fibres have a definite alignment – they follow the direction of the web of paper as it is pulled off the machine. This process is limited to papers of less than (10lb) 450gsm. The two sides of the paper are very different from one another. Machine-made paper is less dimensionally stable than the other kinds so it is inclined to cockle when damp. It will also tear easily in one direction.

Wove and laid papers

Wove paper is formed on a woven mesh and has a less distinctive surface than laid paper which has

light. When the paper is the right way round the watermark reads correctly – on the wrong side it is reversed. Machine-made paper has two distinctive sides – often these offer different effects, so you have a choice of which to use. Handmade paper is the same on both sides.

Choosing paper

The paper you use will depend on the medium you are working in, the purpose of the drawing and the way in which you want to work. For watercolour and other washes you need a heavy, well-sized paper or a lighter paper which will have to be stretched to prevent it cockling. Cartridge paper is a smooth, well-sized paper ideal for pencil, crayon, and pen and ink line work. Pastels require a paper with a rough surface (tooth) which will hold the pastel pigment.

▽ *Here coloured pencil is used on a mid-tone Ingres laid paper. The pencil provides a range of lines and solid tones to give a lively impression of the subject.*

△ *A soft, black EB pencil picks up the pitted texture of rough, watercolour paper.*

◁ *In this portrait, oil pastel is used on smooth white Arches cartridge paper. The artist has used bold sweeping lines – but notice the sensitivity of the lines on the arms and hands.*

21

LIGHT AND TONE

Without light you cannot see form – this may seem obvious but it does underline the special significance light has for the artist.

Light gives us two other qualities: dark – its opposite – and the half-tones which fall between light and dark. The concept of tone is one you need to grasp. Unfortunately, the word has many meanings depending on the context. Here we are using it in a very precise way to describe the lightness or darkness of an object or a colour. In this particular sense tone is most often described as 'tonal value' or simply 'value'. (You will find the word value used as a synonym for tone in American art books.)

Place a white jug in a darkened room, then light it from the side with a single light source – an anglepoise lamp, for example. You will see that it has a very bright side and a very dark side. You will also notice that, as the light travels across its curved side, there is a gradual transition between the lights and darks.

Now fold a piece of white card and stand it up so that one flat surface is at right angles to the light and the angle of the fold faces you. You will see one

The yellow arrows indicate the direction from which the light comes. You can see the way the direction affects the location of the shade and the shadows.

bright surface and one dark surface but this time the transition between the light area and the dark area will be abrupt, creating a crisp edge along the fold.

It is the contrast between the lights and darks and the distribution of the half-tones which allows us to see and understand form. By organising the tones carefully you will be able to depict solid forms convincingly in your paintings and drawings.

At first it is very difficult to see tone because colours, patterns, shadows, reflected light and different light sources interfere and cause confusion. But if you screw up your eyes and really concentrate you will find that the lights and darks are exaggerated so that their distribution across surfaces is easier to see. Black and white photography is a good example of the use of tone (lights, darks and half-tones) to describe form.

The head is also modelled by the light that falls on it. Here the artist assumes light from different directions for each study. Notice that he has used different shading or rendering techniques. For the head on the right he uses meticulous rendering in coloured pencil; on the left he has simplified the areas of light and dark to give the head a sculpted appearance, while bottom right he uses freely applied rendering in pen and ink.

GETTING TO KNOW YOUR PENCIL

A soft pencil such as a 6B will quickly lose its sharp tip and become blunt. A soft pencil is in many ways more flexible than a hard pencil. When it is sharp it can be used to create a fluid line with thicks and thins, and once it has become blunt it can be used to create a broad dark line.

It is worth spending time getting to know media. Start with pencil and cartridge paper. Take an HB or a B pencil and see what sort of marks you make when you hold the pencil tightly, low down and work from the wrist. Now try holding it more loosely and work from the elbow. The first set of lines will be controlled and contained – the second will have a more flowing character.

The lines produced by a pencil point can vary in thickness, darkness and length. Hard pencils retain a sharp point for a long time and can be used to produce a line of constant thickness. Because they can be sharpened to a very fine point they can also be used to create very fine lines.

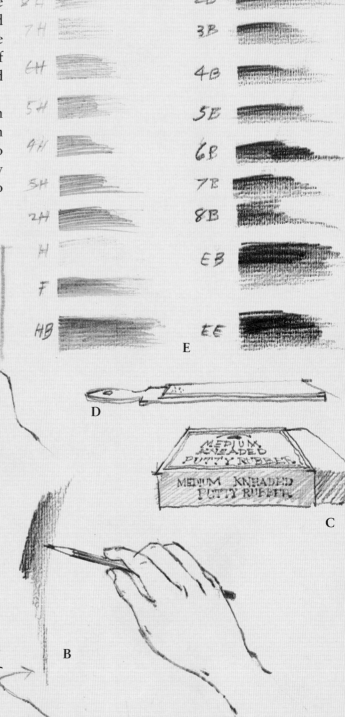

It is best to sharpen your pencil with a craft knife. (Always work away from your body to avoid injury.) A pencil sharpener is likely to break the lead within the shaft, while a blade is kinder and also allows you to modify the shape of the tip, from a sharp point to wedge shapes. You can soften the sharpened point by working it on a sheet of paper or very fine glass paper.

The type of paper will also affect the quality of the line. Smooth paper encourages a fluent line with an even distribution of tone along the length of the lines. These have a clarity of edge.

By varying the pressure on the lead from firm to light along the length of the line, you can create lines with interesting thicks and thins.

Make the same marks on a rough paper and you will find that you achieve a greater depth of tone because the surface traps and holds the graphite.

A *Sharpening with a craft knife*
B *Ways of holding a pencil*
C *Kneadable rubber*
D *Emery board*
E *Pencil tones*

The line is a marvellous means of description and of expression. The quality and character of a line depends on many factors – on the medium, on the way you hold the instrument, on the surface and on your intention.

The paper texture also makes the lines look rougher and less crisply defined.

An HB or a 2B is probably the most popular pencil, but it is worth experimenting with the possibilities of a hard pencil.

There are many different types of eraser on the market. The most useful is the putty or kneadable rubber which can be moulded to a point and allows you to erase fine details and even to 'draw' highlights into areas of tone.

If you are working with soft pencil you may need to fix the work with a spray fixative.

Pencil holders or extenders allow you to use pencil stubs.

TECHNIQUES

RENDERING WITH PENCIL

Don't underestimate the humble pencil, the most versatile of all the drawing media. It is cheap, portable and available everywhere. And the equipment you need to use with it is simple – paper, a blade to sharpen the pencil and possibly an eraser. Pencils are available in many degrees of hardness, from very hard to extremely soft and black, so you can create a range of tones from light to dark.

For the drawing on the opposite page the artist has used pencil to create solid tone which almost replicates the effect of a half-tone black and white photograph. He has done this by careful shading with regularly spaced strokes. A useful exercise which will help you understand tone is to make a tonal scale using several grades of graphite pencil. The artist has done this below using five grades of pencil: 2H, HB, 2B, 5B and 7B. Now make a tonal drawing using these five tones.

Start by simplifying the tones. If you screw up your eyes and squint at the subject you will be able to identify the lightest and darkest areas, and with practice you will be able to isolate the shades in between.

Next you need to get to know your pencils. Start with a large sheet of scrap paper and practise laying down areas of evenly gradated tone.

The softer grades can be blended with a stump, in fact the soiled stump can be used to apply tone to areas which have not had pencil applied to them.

You can load the stump by rubbing a soft pencil on paper, or by rubbing the stump in graphite powder shaved from a pencil. It is difficult to be precise with the stump, but you can clean up edges and create highlights by working back into the toned area with an eraser. Stump work, or stumping, was much in vogue at the end of the last century and school children were taught this method of drawing which avoided the use of line. Like any technique it can become mannered if taken to extremes, so use it here and there and avoid over-use.

You will also find that soft grades of pencil tend to smudge and your drawing may become unpleasantly grubby looking. A sheet of paper under your hand will prevent this. You will find that the texture of the paper has a marked effect on the way the pencil moves over the surface and on the final appearance of the drawing. With time and experience you will be able to exploit this quality.

For this drawing of the Mansion House in the City of London the artist, Albany Wiseman, used five different grades of pencil – see the tonal scale

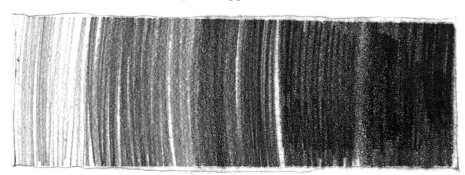

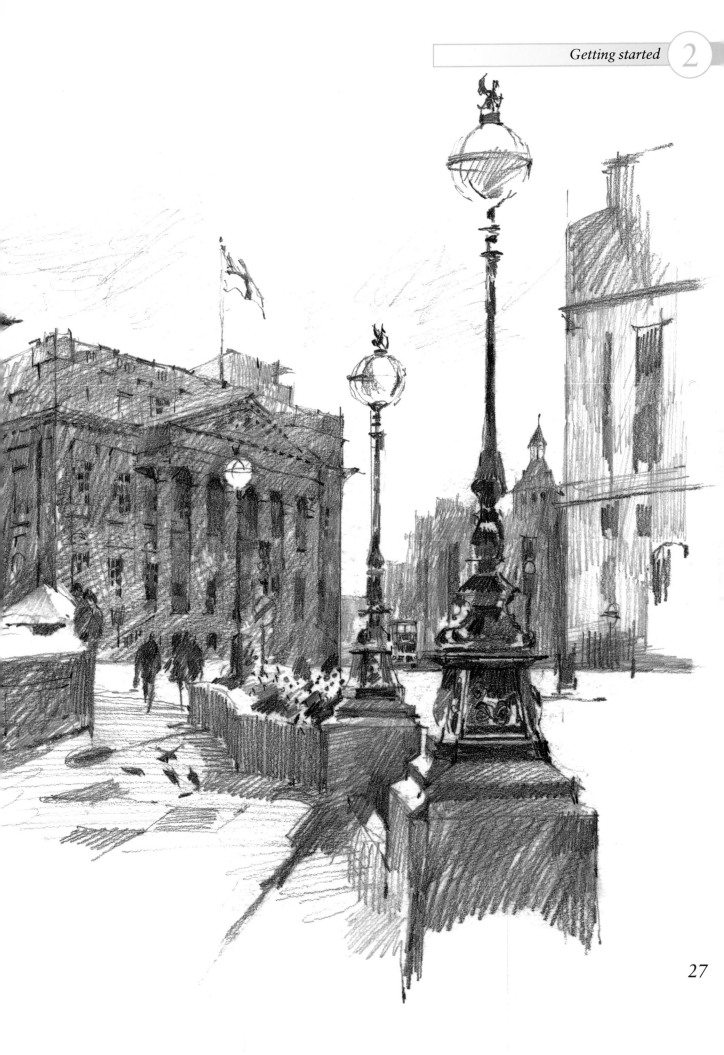

TECHNIQUES

RENDERING

Pencil is a highly responsive, flexible and appealing medium. It can be applied in a variety of ways to create areas of line, tone or texture. Pencil lines can be soft and sinuous, bold and vigorous or controlled and crisp. You can create highly worked drawings with carefully modulated tones of enormous subtlety or bold energetic drawings in which the lines have a calligraphic quality.

The type of mark depends on the hardness or softness of the pencil, the way it is applied to the surface, the sharpness of the drawing tip, the shape of the drawing tip, the nature of the surface and the degree of pressure applied.

Shading

The simplest method of building up tone is to make back and forth movements with a soft pencil which should be held loosely in the hand. The pencil marks should be placed side by side and close to one another. Afterwards the pencil marks can be blended with the fingertips or a stump.

Pencils are capable of creating a great variety of marks and textures but because they are so familiar

▷ Hatched tone was created with pen and ink. The regular horizontal lines were laid down first and then diagonals.

△ Here the artist used coloured pencil to lay down carefully graded colour. The laid texture of the paper gives the tone a broken quality.

we rarely spend time getting to know them and exploring their potential. Here we look at some ways of creating tone and texture.

Use a sheet of scrap paper to explore different ways of creating tone. Hold the pencil firmly, close to the drawing point, and lay down a patch of tone. Now try changing direction, pivoting from the

◁ Patches of regular pencil hatching capture very precisely the character of crumpled paper.

wrist. A random, multi-directional mesh of lines will quickly build up. Now try laying down regular hatched lines – resting your wrist on the paper will give you more control, but will limit the area you can cover at any one time. If you need a broader gesture you can grip the pencil further up the shaft, holding your hand off the paper.

Explore regular, mechanical hatching and cross-hatching. Then try stippling using a variety of dots and dashes. To create dark tones you will place the marks close together, for lighter tones they will be more sparsely spaced.

When you have satisfied yourself that you have these techniques under your belt you should experiment with making the same marks on different papers and with different pencils and with pen. You will find that textures rendered on a highly calendered, smooth paper will look crisp and even, while on a rough paper the recesses in the paper interrupt the line, creating a softer more velvety texture.

▷ *A variety of hatched marks in pencil capture the solidity of this figurine.*

◁ *Here the same figure is rendered with a loose web of hatched marks in pen and ink.*

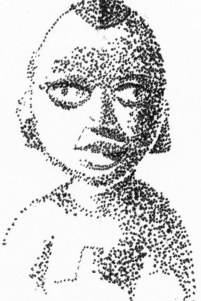

▷ *Here stippled dots allow the form to emerge from the paper.*

29

TECHNIQUES

NEGATIVE SHAPES

If you read about painting and drawing you will come across this term quite frequently. It means the spaces in between the solid forms. These have considerable importance for the artist – in some cases they can become more important than the objects themselves.

Why should you pay attention to these 'negative' or empty spaces? There are several reasons. Firstly, they can really help you draw accurately. This is because when you look at an object, like a jug or a coffee cup, you immediately start to interpret what you see, check it against things that you know and recognise and then subconsciously decide 'OK, I *know* what that looks like'. Immediately you stop analysing and looking, you switch off and put down what you *know* to be there rather than what you can see is there. In many ways it is more difficult to draw familar subjects. By focusing on the spaces in between objects you present yourself with an unfamiliar subject and force youself to really look and sort out what you are seeing.

Negative shapes can also be important elements in a composition. When you are considering composition – the design of a painting or drawing – every shape and every space has to be considered. It may help if you make a thumbnail sketch in which you block in the negative shapes in black so that you can see them more clearly.

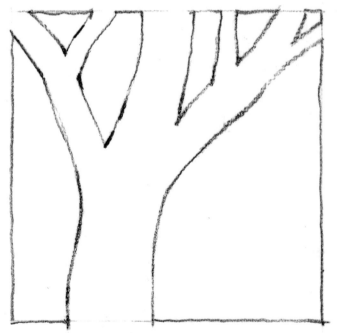

△ *In the drawing above the artist has drawn a tree in pure outline. The trunk and branches are recognisable because they are familiar, although the way the image is cropped by the frame and the lack of tonal shading renders it more abstract. If you trace off this shape and add some shading around the trunk and branches – allow the shading to curve around the trunk – you will find that it reads even more convincingly as a tree.*

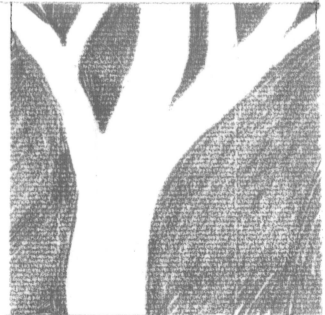

△ *Here, the spaces between the branches and the spaces trapped between the tree trunk, the branches and frame, have been blocked in with solid colour. You can see the way this draws attention to the negative spaces and renders a familiar form less familiar.*

Three different subjects are drawn as 'negatives'. Kitchen utensils in a jug and a head in profile are instantly recognisable. The third image is more confusing but the strap is a clue – it's a camera with a long lens.

PROJECTS

WOODWORKING TOOLS

An assortment of old tools provides an ideal subject for this exercise. See if you have something similar – tools, kitchen utensils, children's toys. Arrange them against a plain background. In this exercise you are going to check the shapes and sizes of objects against the background and the spaces between them. The reason is that you will have preconceived ideas about what objects look like. The brain is adept at making objects from the information it receives from the eyes, and it needs little stimulus to produce them. But sometimes it can be deluded and come to the wrong conclusion.

By looking carefully at the negatives, at the spaces between the objects you can overcome the brain's tendency to jump to conclusions. By doing exercises like this every now and again, and by applying this sort of thinking to all your drawings, you will gain more insight and your drawing will become more accurate.

△ **2** *The artist started by making a pure negative drawing, using only outline and ignoring surface detail. To emphasize the negatives he has filled in the trapped shapes with colour. By extracting these shapes and ignoring the objects you could create a pleasing abstract image. Alternatively, the spaces could be filled in with solid tone and all line avoided. Keep checking to ensure that you have got the shapes right. Soon you'll find you have forgotten what you are looking at.*

▷ **1** *These old woodworking tools have interesting and complicated silhouettes. We arranged them against a plain background, spreading them so that they butted up against each other, trapping strange shapes. Find a similar subject for yourself. Look for flat objects so that you limit the depth and perspective elements of the subject. It works best if you view the arrangement from a high viewpoint so that you can see the spaces between the objects.*

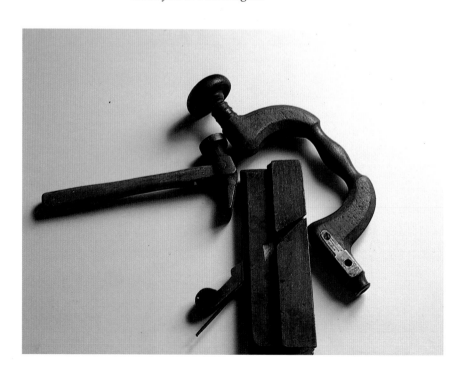

▽ **3** *Make a simple pencil line drawing, checking one shape against the next. Look at the positive shapes, but check their accuracy against the negatives.*

▷ **4** *Here the artist elaborates the subject by adding some tone. He is using an EB pencil which is matt black and waxy.*

▽ **5** *In the final drawing you can see just how the tone brings the whole image to life.*

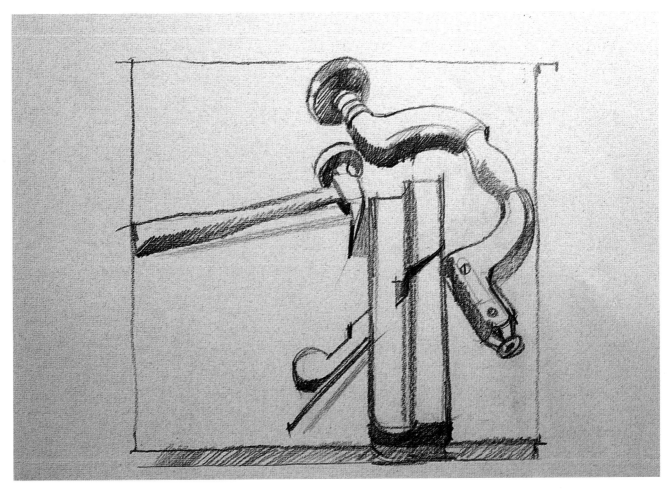

33

Looking and seeing

THE GREAT ARCHITECT Le Corbusier (1887–1965) made a distinction between looking and seeing which is useful for the artist. He defined looking as the process of collecting, listing and cataloguing visual data. Seeing takes the process further – it is about understanding, making connections and finally creating.

You can draw simply to record the appearance of things but drawing is more than making marks on a sheet of paper – it is also a special way of thinking and processing information. This rigorous, analytical drawing allows you to understand how a thing exists and works.

Strangely, the more rigorous and strenuous your approach to drawing, the more liberating the experience will be. With improved skills and understanding you will be freed from the necessity of simply recording what you see so that you can be really inventive and creative.

In this chapter we look at some exercises designed to improve your ability to look and to see.

▷ *The artist, Annie Wood, was entranced by the vivid colours and textures of the vegetables and the pomegranates and also the linear qualities of the artichoke, the basket and the leek. She has chosen to use vigorously applied line to build up a complex web of fresh, strong colour. Her clarity of vision allows us to see everyday objects in a new and exciting way.*

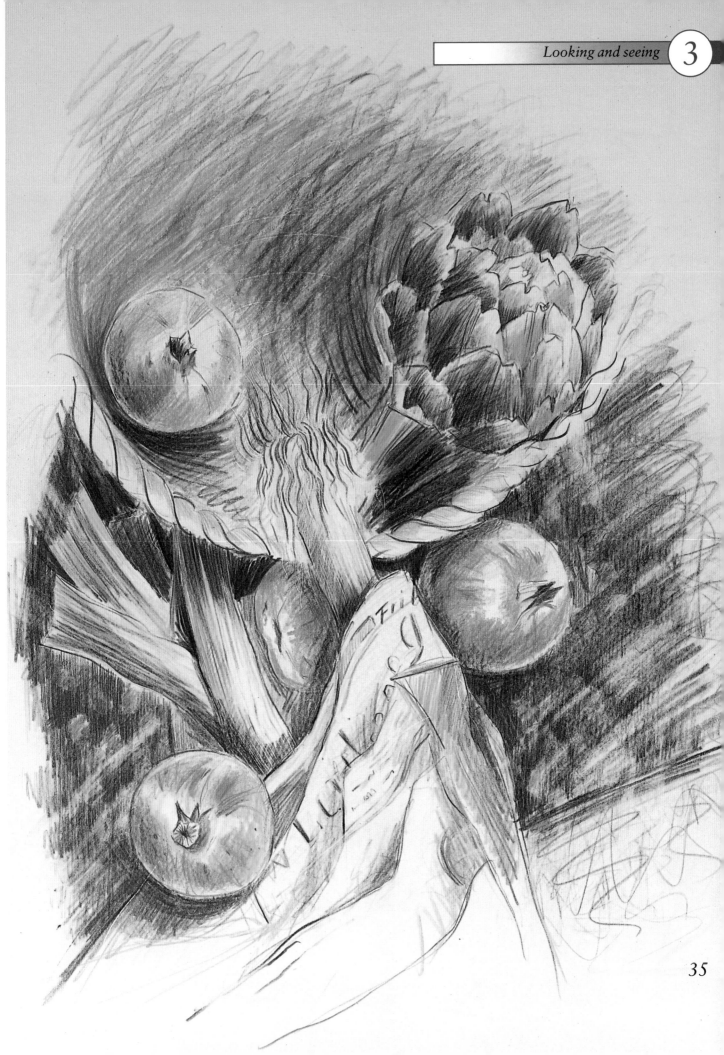

TECHNIQUES

SEEING SIMPLE SHAPES

When you first look really hard at a still life group or a figure it is easy to become confused. We take so much of our visual world for granted that when we start to question what we are seeing – as we must if we are to translate it into line or line and tone, it suddenly becomes difficult to understand what is going on. It is especially difficult to understand the solidity of objects. But there are some simple geometric forms which are familiar and relatively easy to comprehend.

An effective strategy, which you may find useful, is to mentally translate your still life group into these familiar forms. Take a still life group like the one on this page – each of the kitchen utensils can be translated into a geometric form. If you look at the coffee pot you can see that it is basically a 'cone' shape with the top sliced off, and a curved lid, a

These simple forms can be seen as the basis of almost any structure – including the human form. Copy or trace these shapes, leaving out the shading. As pure outline they could be interpreted as flat shapes, though the eye quickly reads as clues the ellipses which form the base of the cone and the bottom and top of the cylinder. But see how much more solid they appear when you add the shading.

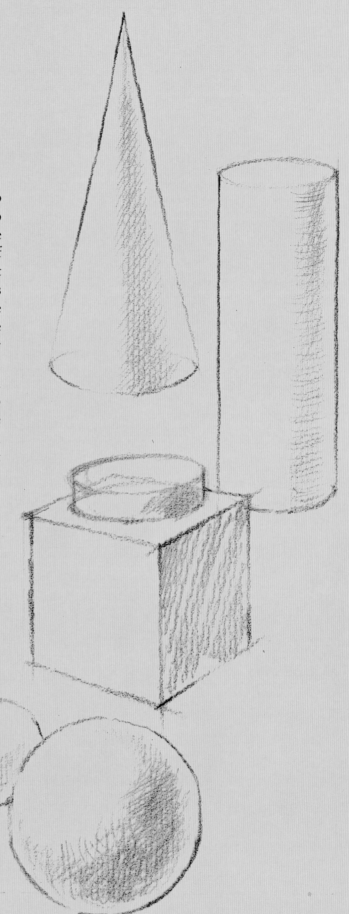

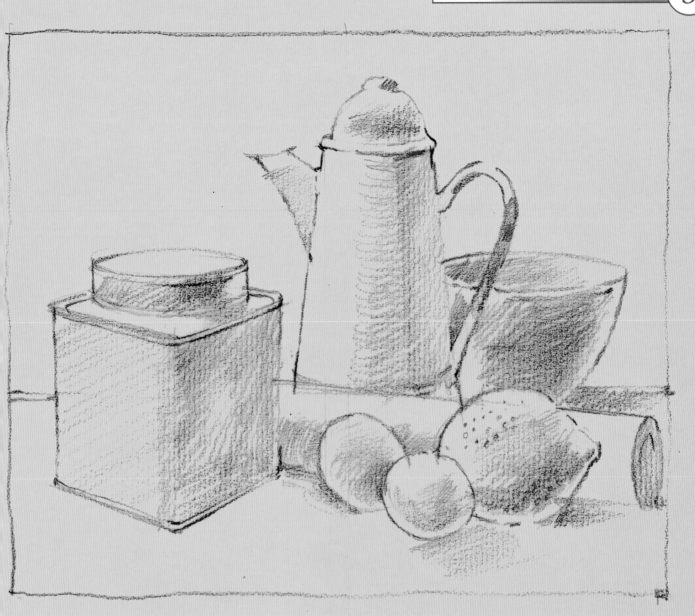

handle and a spout added. Then look at the canister – that translates into a cube with a cylinder through the middle. The rolling pin is simply a cylinder, while the lemon and the eggs are modified spheres.

This still life group consists of relatively simple forms, but you can also apply this approach to more ambitious subjects. Take a tree for example. There is a temptation to draw it as a flat lollipop shape. But trees have solidity and volume and it is easier to understand that if you can make your mind travel over and around the form, so that you feel the other side. A conifer is a cylinder or a cone shape, while most deciduous trees are variations of the sphere. In fact many broadleaf trees consist of a cluster of modified spheres, each cluster attached to a main branch.

△ *In this still life group we can see the geometric forms easily. The cone in the coffee pot, the cylinder in the rolling pin, the cube and the cylinder in the canister and variations on the sphere in the bowl (a hollow half-sphere), the eggs and the lemon.*

PROJECTS

KITCHEN UTENSILS

This project is based on the concept discussed on the previous page. The best way to put the ideas into practice is to set up a still life group of your own. The kitchen is a good source of likely objects – containers of all shapes and sizes, cooking implements and fruit and vegetables. A rolling pin is a good cylinder, but a spaghetti jar or a large glass or ceramic pot will do as well. For this exercise you should focus on simple shapes and avoid complex organic forms like plants and flowers. We will look at these later.

Organize your still life on a flat surface so that you can view it at slightly below eye level. If you set it on a table, you will need to sit on a low stool – if you want to stand you can do as the artist did here, and set the objects on a raised surface. In this way you will be able to see the objects one behind the other – if you put them on a low surface you will see them from above. This can make a very interesting study – but it gives you fewer spatial clues and has a more abstract quality. To keep things simple put a sheet of plain card or paper behind the group. Later you might like to elaborate with complex draped fabrics.

Pin some cartridge paper to a board, using masking tape or drawing pins. You can buy a proper drawing board if you prefer but a sheet of ply will do just as well. The drawing board gives you a firm surface which you can rest on your knee – you can hold it up from time to time to see how the drawing is progressing.

For this exercise the artist used pencil on a buff coloured Ingres paper. This type of paper has a distinctive laid texture which gives a special sparkle to the drawing.

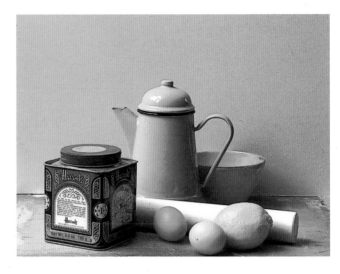

△ **1** *Some common household objects grouped together make a useful study. Notice that they have been placed so that one form overlaps another – this makes for an interesting composition and will also help you achieve an accurate drawing.*

△ **2** *This picture shows the way the group has been rigged up. You can also see the relationship between the artist, Albany Wiseman, and the objects, which are placed just below his eye-level. And his working surface is positioned so that he can transfer his gaze from the subject to the drawing surface by simply moving his eyes – this means that he can draw very directly and therefore also accurately. Make yourself as comfortable as you can when you are settling down to work.*

△ 3 The artist is working with an EB pencil sharpened to a fine point. Start by studying the group carefully for a few moments. The first mark is always the most difficult, so get that over with. Draw lightly but not tentatively. In this way you give yourself the option of redrawing the lines. If your first marks are too dark they will overwhelm the drawing and if you need to correct you will have to erase them. Try and avoid using the eraser as you draw – you can use it to create highlights or to tidy up the drawing at the end.

Albany started by establishing the horizontal of the far edge of the drawing board, the verticals of the canister – then the baseline and the top of the canister. It is important to get the angles right, so really screw up your eyes and allow them to travel from one object to the other and back again. If you draw each object in isolation you will find that the drawing begins to go awry. If this is your first drawing it may go wrong – don't worry and above all don't tear it up and throw it away. Persevere . . . and remember this is an investigation so the process is more important than the final drawing. The artist then puts in the coffee pot – always seeing it in relation to the other objects.

▽ 4 All the main elements of the drawing are now established. Notice that the artist hasn't used a single enclosing outline, but has found the shapes by using several lines. You may well have to use more lines to find the correct shapes but don't worry – Albany is a professional artist with a lifetime's experience and you can't expect to match his skills straight away. There are several points to note at this stage. You will see that the artist has constructed the ellipses on the top of the canister and the bowl (see page 89). Notice also that he has drawn the ellipses which give the curve of the ridge on the lower part of the coffee pot. This is because he is aware of the back of the pot even though he can't see it. By constructing the ellipses he created a more accurate curve. You'll also see that the eggs and lemon are superimposed over the rolling pin as if they are transparent. By sketching in forms that you cannot see you can produce a more accurate drawing.

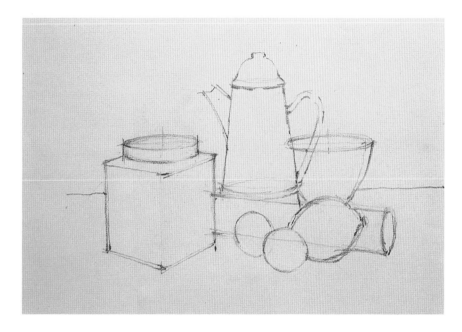

◁ 5 Satisfied that his drawing is accurate, Albany now starts to emphasize one of the lines to give 'colour' to the drawing. Here, for example, the canister has a metal rim which casts a shadow: by darkening this line he captures the depth of the metal lip.

▷ **6** *He now adds some dark and mid-tones using loose hatching and cross-hatching. You'll find that if you screw up your eyes you will be able to see the lights and darks more clearly. Start by working fairly lightly – it is easier to darken an area of tone than to lighten it. Draw what you see, but at the same time 'feel' the bulk of the object.*

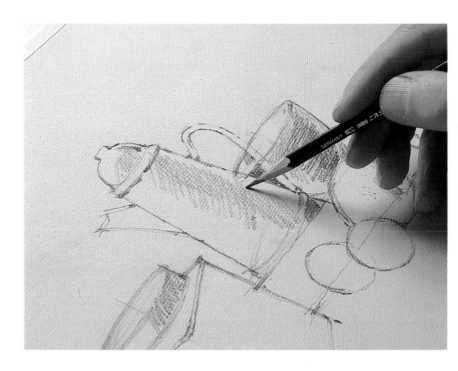

▽ **7** *Protect the drawing from being smudged by your hand and arm by laying a piece of paper under your hand. Here, the dark areas where the bowl is in shadow are being laid in, defining the handle of the pot.*

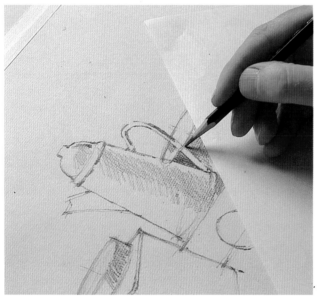

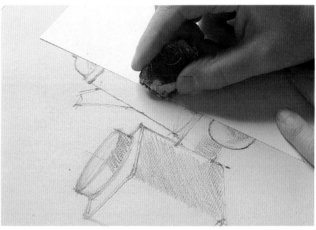

△ **9** *Here paper is used as a mask again, but this time he is using an eraser to create a crisper edge to the shading on the coffee pot.*

▷ **8** *The side of the canister which is turned away from the window is in its own shadow. The artist uses a sheet of paper to mask the point at which the adjacent faces of the cube meet, allowing him to work quickly with vigorous but lightly applied hatching. Without this, he would have to work more carefully and slowly.*

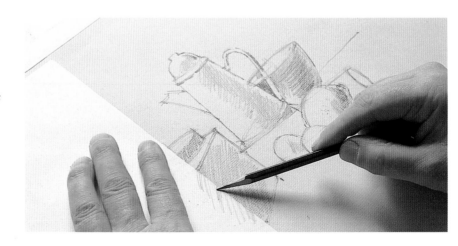

▽ **10** *This detail allows you to see the variety of marks that the artist uses – notice the speckled marks used to describe the pitted texture of the lemon peel. You can also see the way the ridged surface of the paper breaks up the pencil shading to create a texture.*

▽ **11** *You can see that these objects are rendered with a convincing solidity. While drawing what his eyes could see, the artist was also aware of what his memory told him about the objects. So you can see that the shading on the rolling pin is curved to follow the form of the cylinder. The curves of the top of the canister, the coffee pot, the end of the rolling pin and the top of the bowl are drawn as ellipses – because he knows that they are actually circles seen in perspective.*

TECHNIQUES

ANALYSING FORMS

We have already looked at the way in which apparently complex objects can be re-interpreted in terms of more familiar forms. But all forms are easier to understand if we simplify them. Flowers are an enchanting but daunting subject. They are beautiful and almost limitless in their range of shapes and forms. If you generalise too much you lose their character; if you become too absorbed with the detail you will get lost, disheartened and sacrifice the spontaneity of the drawing.

Everything in the natural world conforms to a sort of pattern. It may not be regular but if you look carefully you will find that there is a pattern – nothing is random. Trees grow in a particular way. In some the branches spiral up the trunk, while in others they emerge as pairs or alternate up the stem. Flowers also have growth patterns.

Even flower heads can be broken down into basic forms. Take the lilies illustrated on this page. If you tried to draw each flower head petal by petal, the drawing would lack structure and conviction – it would be flabby and unconvincing. But Albany has looked at the overall form. As you can see, each flower conforms to a trumpet shape. The six petals sit within that cone. In the pencil drawings you can see the way the artist has looked at the trumpet shapes from several angles – seen head-on the tips of the petals describe a circle. This circle, when turned to a three-quarter view, conforms to the rules of perspective and becomes an ellipse.

You'll find that other flowers can be treated in this way — daisies and chrysanthemums, for example, which are basically circular with a shallow cone-shaped base.

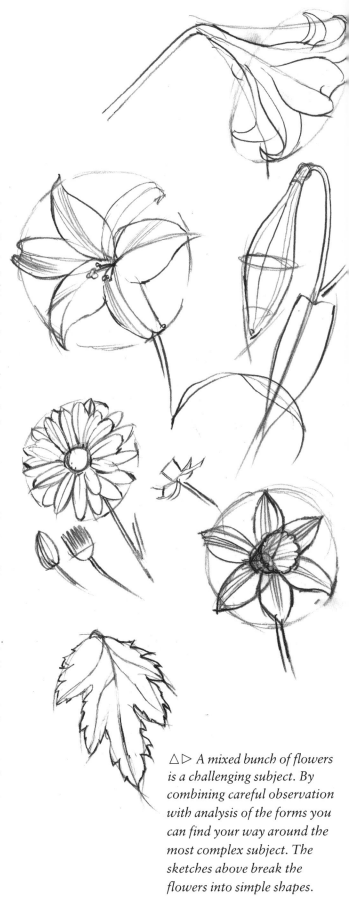

△▷ *A mixed bunch of flowers is a challenging subject. By combining careful observation with analysis of the forms you can find your way around the most complex subject. The sketches above break the flowers into simple shapes.*

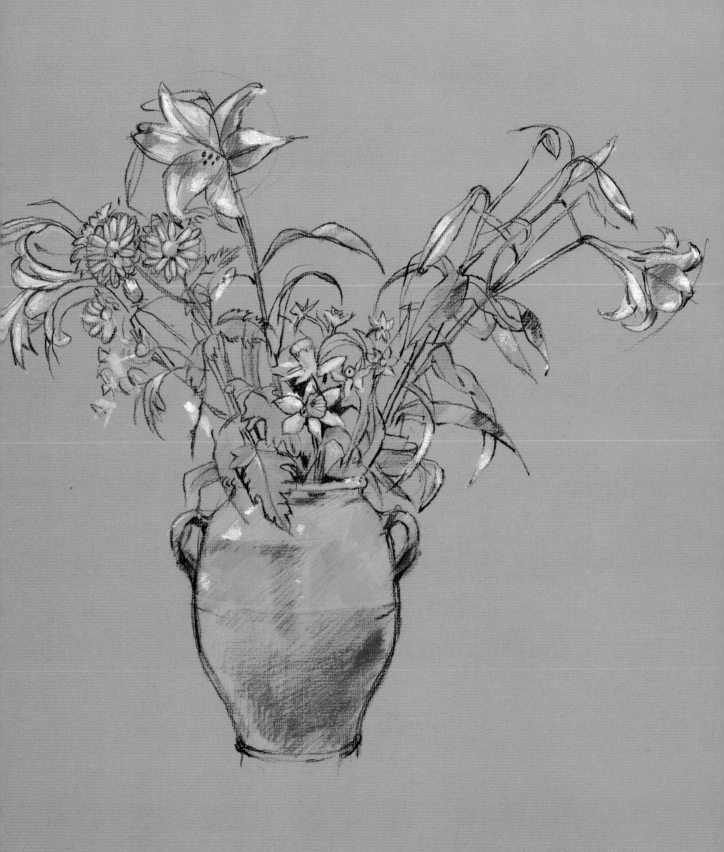

PROJECTS

LILIES

For this project we deliberately selected flowers with a dramatic and distinctive form. We used two stems only as we wanted to be able to see the forms as clearly as possible. This approach can just as easily be applied to a large bunch of flowers, but start by making things easy for yourself. The flowers you use will depend on what is in season.

Study the subject carefully before you start. Make sure you can see the forms clearly and that the lighting is good. A bright light from the side or slightly in front of the group will give you interesting shadows and plenty of contrast. This will make it easier for you to see and understand the forms so you can draw them accurately.

You can use natural light from a window or use a desk lamp or spotlight to provide a directional light which will model the forms.

Now make a sketch in which you analyse the forms. Walk round the group if you are puzzled. By looking at it from different angles, and making a series of drawings from each of those locations, you will really begin to understand how one part of the plant relates to another. You will also begin to understand the flowers as a three-dimensional form. It can otherwise be difficult to keep this three-dimensionality in mind when there are so many spaces and gaps between the stems, leaves and petals.

You create a sense of space by overlapping forms, one flower head with another. Our brain immediately sees the flower which is incomplete because it has been overlapped as being farther away. Flowers at the back of the group will appear smaller than those at the front of the group and this too creates a sense of space in the drawing.

The artist used oil pastel on tinted Ingres paper.

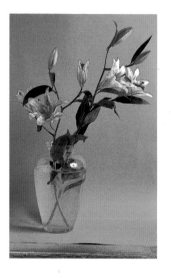

◁ **1** *These spectacular flowers with blooms trumpet-shaped in profile and star-shaped when seen from in front, and with compact, cigar-shaped buds and simple lance-shaped leaves were ideal for this analytical drawing.*

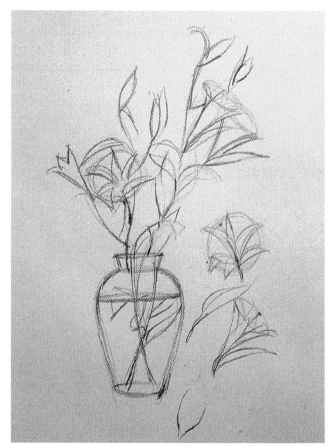

△ **2** *Albany started by making a pencil sketch, working quickly and looking for the simple forms. If you get the broad structures right you can superimpose the details. The problem here is a conceptual one: you have to understand the forms as solid, three-dimensional objects. Of course, you could deliberately flatten the forms to create a drawing which emphasizes the pattern-making aspects of the subject, but this is not the purpose of this particular exercise in drawing.*

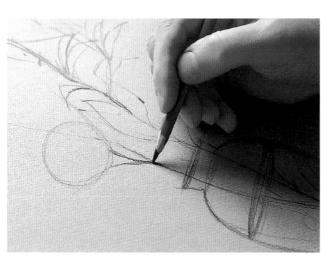

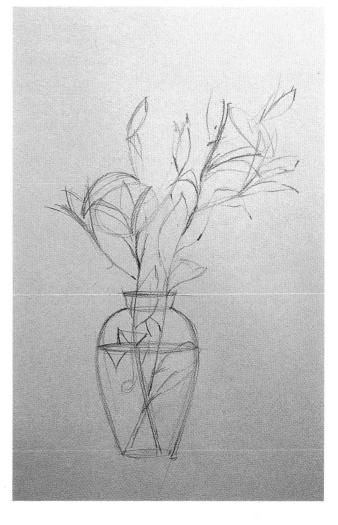

△ ▷ **3, 4** *Using a soft pencil (2B) the artist starts to establish the drawing. Notice some proportions before you start. In this case, the flower spray is more than half the subject – the vase beneath less than half. Plot these measurements on your support, mapping out approximately the area you want it to fill. If you simply start in the middle and work outwards you may find that the image doesn't fit on the paper or that it ends up very small. You have to think of your drawing in relation to the four edges of the paper. Concentrate, looking constantly from the subject to the support and back again. Allow your eye to travel across the image, assessing angles, comparing one distance with another, mentally making measurements all the time.*

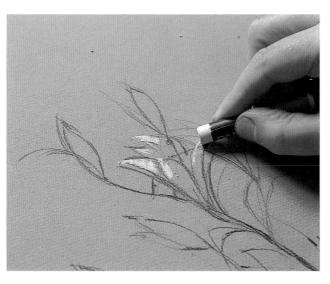

△ **5** *Now start to lay in colour, using soft pastels. Here the artist uses white pastel for the petals. The white shows up well against the mid-toned background. On white paper you would have had to work in an entirely different way.*

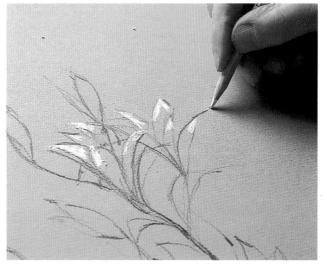

△ **6** *Oil pastels are fairly blunt though they can be sharpened. Nevertheless, they are rather crumbly and therefore rather awkward to use for adding intricate detail. Here the artist uses a white pencil to lay in fine details like the sharp tip of the petals.*

45

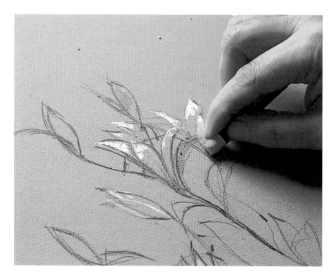

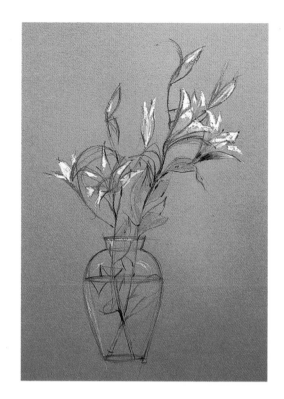

△ 7 *Using a soft sage green, he touches in the leaves. He doesn't fill in the pencil outlines but merely suggests the areas of most intense colour, allowing the putty-coloured paper to stand for the mid tones, with the pencil giving the darks. With a bright pink pastel he lays in the pink blush at the heart of the flower, giving the drawing an essential touch of vivid colour.*

△ 8 *The drawing is coming together. The lively, flowing pencil lines capture the sinuous forms of stems, leaves and petals. The brilliant patches of oil pastel describe the freshness of the flowers and leaves.*

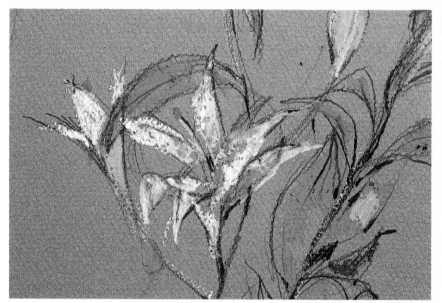

△ 9 *Using a white pastel on its side, the artist applies a film of colour which captures the transparency and reflectiveness of the glass vase of water. You can see the way the texture of the Ingres paper breaks up the layer of pastel, creating a scintillating broken colour effect.*

△ 10 *In this detail you can see the way the underlying drawing provides a structure for the image. The line holds the drawing together and gives it a special character. The lovely crumbly texture of the pastels gives impact and colour. But it is all very simply and freshly rendered — nothing is overworked.*

▷ 11 *The final image is simple but very effective. It is particularly interesting to see just how much the toned background contributes to the drawing. The artist has combined clarity of vision with rigorous observation and lightness of touch.*

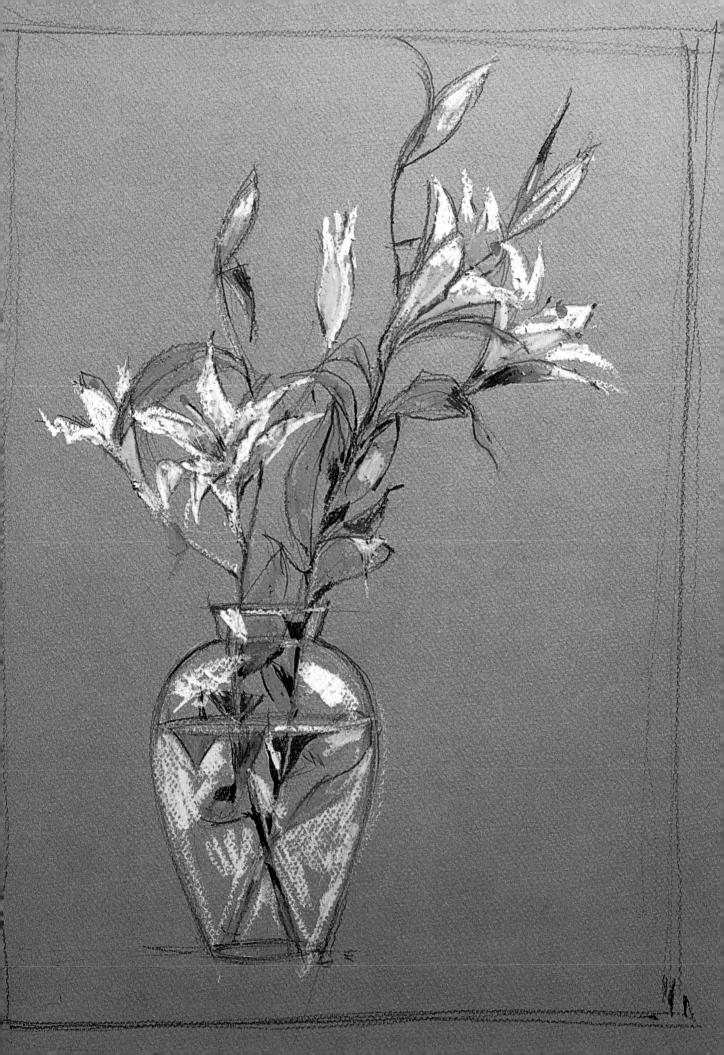

LOOKING AT LINE

The line is a marvellous means of description and of expression. Shapes are enclosed and broken down by lines, so that we immediately try and read known forms into even the most random scribbles. The quality and character of a line depends on many factors – on the medium, on the way you hold the instrument, on the surface you are working on and of course, on your intention.

The line is chameleon-like in its manifestations. It can be thick or thin, straight or curving. It may be continuous or broken, close-packed or widely spaced. It can be regular and orderly, or have a random, meandering appearance. It can be bold and purposeful, short and stabbing, thin, wiry and nervy, agitated, smooth and fluidly flowing. Curving lines are graceful, straight lines are forceful, jagged lines have a restless quality and long sweeping lines suggest movement or growth. A ruled line has an impersonal, rather abstract, mechanical quality. It has no sense of being made or of the direction in which it was drawn.

Even accomplished artists sometimes neglect this aspect of their work, resulting in drawings which are anonymous – even insipid. If you get to know, value and enjoy your line, a less-than-perfect drawing will have confidence and flair.

Practise on large sheets of cheap paper. Explore as many drawing tools as you can lay your hands on and make' as many different lines as you can – flowing ones from your shoulder, short stabbing

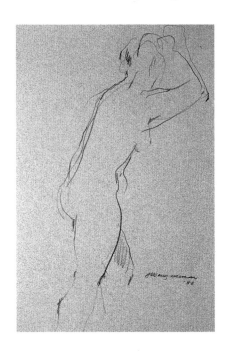

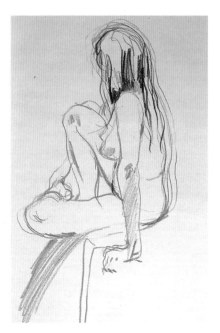

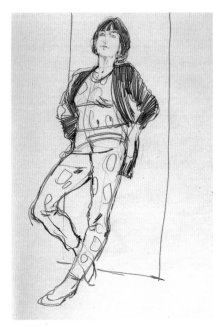

△ All these drawings are by Albany Wiseman. This nude shows drawing at its most economical and well informed, capturing with a few unhesitating lines the rhythms of the figure and a sense of movement. The darker line on the thigh suggests a strong contrast here with the background.

△ Sanguine and black pencil were used for this study. Line follows form with great confidence, but there is some redrawing around the back and head. The artist was searching for the form – but the repeated lines capture the experience's immediacy and directness.

△ Pencil was used for this very expressive study of a leaning figure. The artist used a varied repertoire of marks, increasingly solid lines define the outline and the 'negative' shape trapped between the legs. Bold hatched marks describe the dark tone of the hair and the jacket – the marks following the fabric's folds.

ones from your elbow, tight scribbled ones from your wrist. Change the width of the line by twisting and turning the pencil. Sharpen your pencil to a fine point, bringing it to an even finer point by sharpening it on glass paper. Make a series of fine lines and then try making the same lines with a pencil which has been deliberately blunted.

A brush gives your line a particularly fluid and flowing character. Charge a brush with ink or watercolour and lay down as many different lines as you can. By pulling the brush along so that the tip just touches the paper you can create a fine line which can be controlled and delicate or hesitant and shaky – either are valuable in the right context. You can propel the brush across the paper with big, bold sweeping strokes, or use an attacking movement which forces the brush to bounce across the paper surface creating a discontinuous line.

Make your line move in different directions – this will force you to move your hand in unaccustomed

ways. You will find that the way you hold your pen for writing is too restricting. People usually write with their hand supported on the paper – as soon as you lift your hand from the paper you liberate your hand and arm, and a whole new range of gestures and marks become possible. You may worry that this will make your lines more inaccurate – but you only need this degree of accuracy for details. If your hand needs support to draw a circle, for example, you can use your finger as a pivot.

Try different working positions. Sitting down to draw, you are forced to work in a fairly restrained and contained way. Standing up gives you more freedom to move and you can make bold gestural movements from the shoulder. Standing at an easel is even more liberating – you can stand back from the support to see how the image is building up. You can use the full range of physical gestures and you will be encouraged to think about the overall image, rather than details.

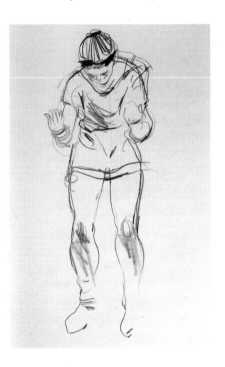

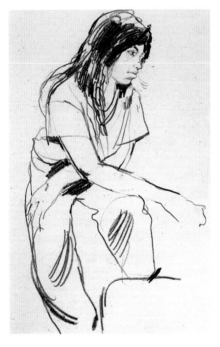

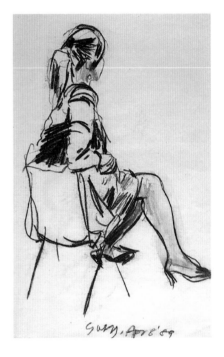

△ *This wonderful gestural drawing captures the sense of movement and the forward thrust of the body.*

△ *Waxy black pencil provides marvellous inky blacks and fine lines which look almost blue-grey. A variety of lines enclose the figure, while others indicate the substance of the fabric and areas of shadow.*

△ *Black and an earth red pencil give this figure study drama and colour. The artist has used solid, stabbing marks which give the drawing spontaneity and a lively quality. The creases on the sitter's jacket follow the contours of her arm.*

TECHNIQUES

MARKS OF THE PEN

Pen and ink has much to recommend it. It is cheap, can be used on many surfaces, is permanent, reproduces well and needs no fixative. When it comes to producing clean precise lines, the pen has no equal. A single pen is capable of producing a whole range of marks and offers great opportunities for producing drawings which are full of character and originality. Setting yourself up with a nib holder and a few nibs will cost you very little. There is a wide range of nibs on the market, but invariably you will find a few that you particularly like. You can still find boxes of old pen nibs which were used by ledger clerks in banks and by children in schools in the days before biros and computers.

The pen does have limitations. It can be difficult to use on large areas – unless you have a great deal of patience. (Brush and ink is more suited to big, bold sweeping drawings.) Pen is very dramatic – it gives you wonderfully stark contrasts of black and white, but it is less good at rendering subtle variations of tone. Pen and ink is also rather unforgiving, in that you don't have the opportunity

to erase. On certain hard surface papers you can scratch off shellac-based inks with a craft blade, or you can paint over errors with white – but you risk losing the freshness of the approach and the integrity of the medium. It is much better to work with a medium's strong points rather than its negative qualities. Working with pen will force you to make decisions, to eliminate and synthesise the important elements of a study. If it makes it difficult to achieve the result you require, in a technical drawing for example, then use another medium. It is a good idea to set yourself challenges now and again – but there is no point in making things impossibly difficult for yourself.

Start with a selection of nibs – perhaps a medium and a fine – and some black waterproof ink. You will also need some blotting paper. Make as many lines as you can with each pen. Then experiment with different ways of building up tone. Try mechanical and regular cross-hatching, hatching and stippling – this controlled regular approach will be suitable for some subjects. Then try making areas of dark and mid tone using looser, more fluid marks which will enhance other subjects.

A good way of testing your skills and learning new ones is to find some examples of work executed in pen and copy them.

Scratching out

▽ **1** *The artist laid down an area of regular hatching then, using a sharp blade, scratched into it.*

▽ **2** *Here you see the pattern created. Notice the scuffed paper surface. If you put ink on to it once the surface has been damaged, it takes the ink in a different way. Because the surface sizing has been removed, the paper will be more absorbent. This quality can be exploited, but be careful if you want to draw back into an area in which you have erased a mistake.*

▽ *For this figure drawing, which was made from life, Albany Wiseman used a fine dip pen. If you study it carefully you will see a variety of marks, each used to perform a particular function. A single fine line is used to describe the profile and the exquisitely rendered hands. On the garment a variety of marks describe the folds of the fabric – they are added very directly, with no fiddling. All the lines have energy and direction. For the hair he used bold lines which capture the weight and solidity of the tresses.*

Make a practise sheet
△ **1** *Using a fine mapping pen the artist traces a thin, nervy line, deliberately allowing the ink to blot.*

▽ **2** *Here he uses his finger to smudge the blots.*

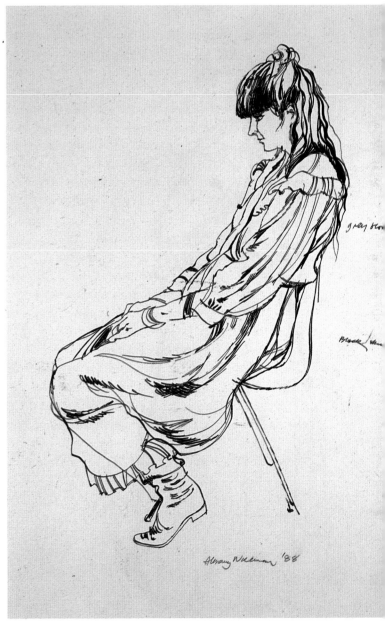

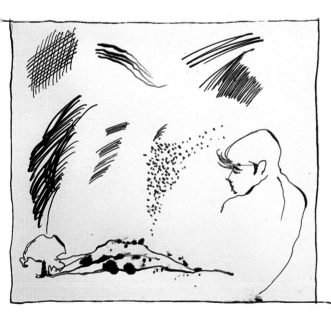

◁ **3** *This is a sheet of marks created with the same pen. Make a practise sheet of your own and explore the range of possibilities.*

PROJECTS

KETTLE AND TRIVET

The purpose of this exercise was to make a drawing using line only. We chose a subject which offered simple forms and set it against a plain, uncluttered background for clarity. You will get most from this exercise if you set up a similar still-life group rather than copying the one shown here. Look for objects that have simple shapes, particularly those which trap space – if you look at our set-up you'll see that the handle of the kettle and the legs of the trivet make distinctive cut-out shapes against the background. These are ideal for an outline drawing. Kitchen utensils like saucepans, colanders and jugs could be assembled to provide a challenging subject.

Albany has used pen and ink, which is an ideal medium for this exercise. Used confidently, a dip pen has a fluidity which allows you to create linework which is varied and characterful. By twisting the nib slightly you can change the nature of your drawing point, the side giving you a thin, nervous line, the tip a wider, more even line. Changing your pressure, grip and the speed of the mark can also modify the nature of the line.

The type of paper used also has an impact. The artist worked on a sheet of Schoellershammer paper which has a very smooth, tough surface – marks can be scratched out without damaging it. It is quite expensive and hard to find but if your local art shop doesn't stock it they may be prepared to order it, or you could get it from one of the many mail order suppliers. Whatever you use, make sure it has a good smooth surface – you may need to experiment with different papers until you find something that suits you. If you are using a fine pen nib you will need a very smooth surface or the nib will drag on the paper and impede the fluidity of the line.

Ink is difficult to erase, though not impossible if you have good paper, as Albany has demonstrated on page 50.

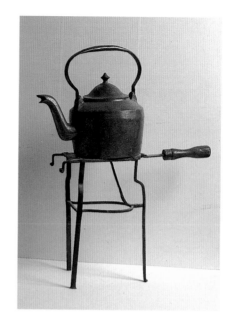

△ **1** *The subject consists of simple forms. You could create something similar by putting a kettle on a kitchen chair or on a step ladder. It doesn't matter how silly the image looks – what you want is something which allows you to concentrate on the linear qualities. Try and set it against a plain wall. If that is difficult, drape a sheet behind the subject to eradicate distracting clutter.*

▽ **2** *The artist matched his lines to what he was drawing. For the straight lines on the base and legs of the trivet he used a series of long, overlapping lines. But the curve of the handle is built up with a series of short overlapping lines. It is difficult to get a single flowing line with a fine nib and, even with a bigger nib, it takes a good eye, considerable experience and even more confidence to draw a long curve with a single line. Concentrate to see that the space that your line is enclosing is correct.*

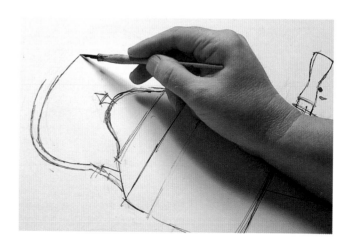

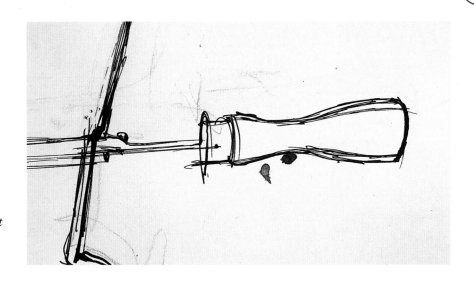

▷ **3** *Here we see an accidental blot by the handle of the trivet. The artist decided it would be distracting, so removes it.*

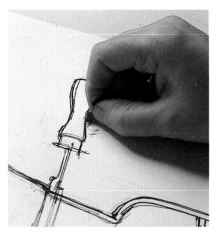

△ **4** *The artist uses a sharp blade to gently scrape the surface of the paper. When ink is removed, the paper can be smoothed with the side of the blade.*

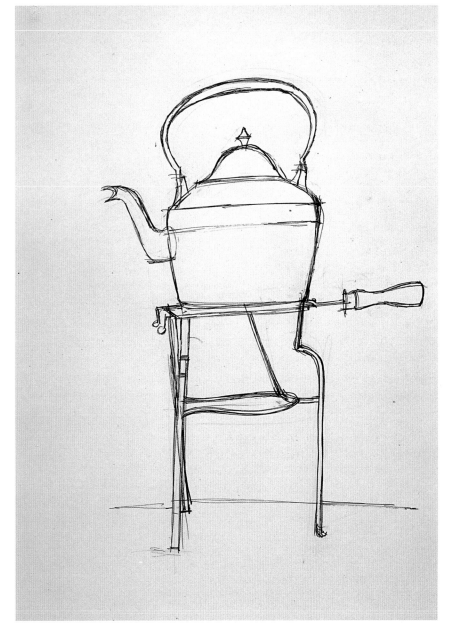

▷ **5** *The finished drawing is economically rendered. The overlapping fine lines give the drawing solidity and character. Your own drawing may not be as neat as this.*

TECHNIQUES

USING TONE

We have already defined the term tone, or value, as the lightness or darkness of a colour. Just as we must learn to see colour, so we must also learn to see tone. It is the distribution of lights and darks over the surface of an object that allows us to understand its form. Look at any subject while ignoring the local colour – the actual colour of an object or an area – and try to see it purely in terms of lights and darks. Half-closing your eyes will help to emphasize the contrasts. A black and white photograph is a good example of a tonal study.

There are two aspects to tone. There is the tone which results from the way that light falls on the subject. It is easiest to understand light if you imagine it falling on a white object. This aspect of light and dark describes the forms and allows us to see shapes and depth. But tone is an aspect of colour. If you screw up your eyes and look at a colour chart you will see that yellow is light in tone while blue is dark in tone. Yellow can be darkened and blue can be lightened.

Get into the habit of making a tonal study of a subject before you paint it. Charcoal is an ideal medium for this because it is capable of rendering subtle tonal gradations. The tonal study will do two things. It will help you understand the forms, and it will also let you see very clearly an important aspect of the composition – the distribution of the lights and darks across the picture area. In a successful painting or drawing these will be arranged in a balanced and harmonious way.

△ *Here the artist has used tone to describe a pepper cut in half. In some places the tone describes areas where the light on the subject is intercepted, creating shadow. But shading is also used to describe the dark tone of the skin of the pepper. The best way to work on this type of drawing is to half-close your eyes; this exaggerates the tonal contrasts in the subject and allows you to see discrete areas of light and shade.*

A useful way of learning about composition is by making tonal studies of the works of the great artists. Take your sketchbook to an art gallery and study the paintings through half-closed eyes so that you can identify the dark masses and the light areas. Make quick drawings of these lights and darks.

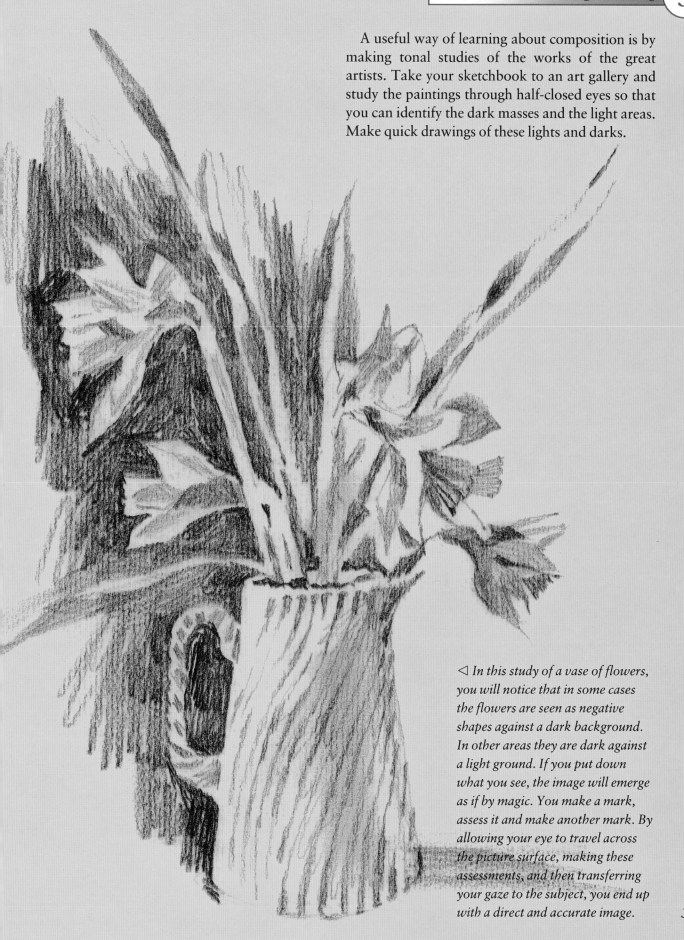

◁ *In this study of a vase of flowers, you will notice that in some cases the flowers are seen as negative shapes against a dark background. In other areas they are dark against a light ground. If you put down what you see, the image will emerge as if by magic. You make a mark, assess it and make another mark. By allowing your eye to travel across the picture surface, making these assessments, and then transferring your gaze to the subject, you end up with a direct and accurate image.*

55

PROJECTS

CABBAGE AND MUSHROOMS

In this project the idea is to find the areas of tone and allow the image to emerge from the surface. Start by studying the subject carefully and decide where the light is coming from. Generally there is a predominant light source, but light bounces around in a space and is reflected back from other surfaces, so the light hitting a surface is a complex matter. Be prepared to be confused.

In a light area the dark tones will appear darker than they are by contrast. If you are not aware of this you may make a light area too dark and will have to make the darks in a darker area even darker to compensate. All tones are modified by adjacent tones – so you must learn to see the drawing as a whole. A useful trick is to have a sheet of white paper and a sheet of black paper. You can hold these up and assess the tone of a given area against each. Alternatively you can make yourself a tonal scale – with black at one end and white at the other and seven carefully graded tones in between. It is a useful and difficult exercise but you will learn a lot and the final tonal scale will be most useful. Use gouache paint as it is easy to mix and correct in tone.

Remember our definition of shade and shadow. Shade is the darkness of the side of an object which is turned away from a light source; it is created because the object itself intercepts the light and blocks it. Shadow is cast by another object intervening between the object and the light source. The terms are often used loosely and, in general conversation, are interchangeable.

The edges of areas of shade and shadow are important because they tell you a great deal about the quality of the light. Strong, directional light casts shadows which are crisp and are strongly contrasted with areas which are not in shadow. The junction between areas of light and dark also

tells you a lot about the forms. So if you fold a piece of paper to form an angle and place it in strong light, the junction between the two planes will be crisply defined – there will be an abrupt change at the point where they meet. Also the tone on each of the planes will be even. On a curved surface the gradations are gentler, sometimes almost imperceptible.

Reflected light can disrupt these effects. So if reflected light hits your sheet of folded paper you may find that there are strange variations of tone on the plane which do not relate to their surface shape.

Edges can sometimes be lost because the tone of an object is the same as that of the background or an object behind it. You should draw what you see. And don't exaggerate unimportant contrasts of reflected light which could confuse our reading of the subject. Use your common sense.

△ **1** *This subject lent itself to a tonal treatment. Other suitable subjects might be a cauliflower, a pile of scrunched-up paper, even the corner of a cluttered room. The artist used charcoal which is an ideal medium for a tonal study. It is available in different widths. Use medium-width sticks of willow charcoal, but a few thin sticks would be useful for adding emphasis and detail here and there.*

△ 2 *Practise on a sheet of spare paper. Here the artist has laid down some charcoal and is blending it with a stump. This is a blending tool made from rolled or compressed paper. Stumps are also called torchons or tortillons and you will find them in any art materials shop.*

△ 4 *Screw up your eyes and start blocking in tone – here the artist is using the side of the charcoal stick. Start by working lightly, otherwise you will find the whole drawing becomes too dark. But if there are some areas which you can identify as the darkest tones you could*

usefully put those in – this gives you a scale to work within. If the drawing does get too heavy and overworked you can remove some of the charcoal by holding the drawing vertically and flicking it with a cloth. This will knock the charcoal dust off the surface.

△ 5 *Already the forms are beginning to emerge and look convincing.*

△ 3 *This is a range of marks made using the tip and the side of the charcoal, blending and smudging.*

▷ 6 *Continue to develop the tones, standing back now and again so that you can see both the subject and the drawing. Carry on drawing what you see – don't falter even if the drawing is looking a bit of a mess. It is better to see it through, and then with the knowledge you have gained start again on a fresh study – but have a break first. This concentrated, focused, analytical drawing is very tiring. You don't realise just how tiring until you have finished.*

△ 7 *Using the tip of a fine charcoal stick the artist adds some touches of dark tone. Solid charcoal has an intense velvety blackness which is very attractive.*

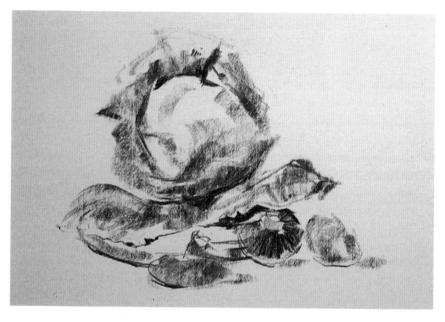

△ 8 *Compare this picture with the last one on the previous page. You can see how the artist has kept the whole thing going, so that no one* area *is developed more than any other. The objects are broadly described, but the essential details are yet to emerge.*

◁ 9 *Using the tip of a slender piece of charcoal, the artist adds textures which describe the surface of different parts of the cabbage. Don't try to be too precise. Look for an equivalent, a series of marks which provide a shorthand for what you are seeing. The stippled marks capture very well the dimpled character of some cabbage leaves, while the rather geometric marks describe the way the veins stand up from the surface in the compact heart of the cabbage.*

◁ **10** *Charcoal is very powdery and will rub off. Spray it with a fixative to make it more permanent. If you haven't got any fixative some hairspray will do – though this is not recommended for important pieces of work which you intend to sell.*

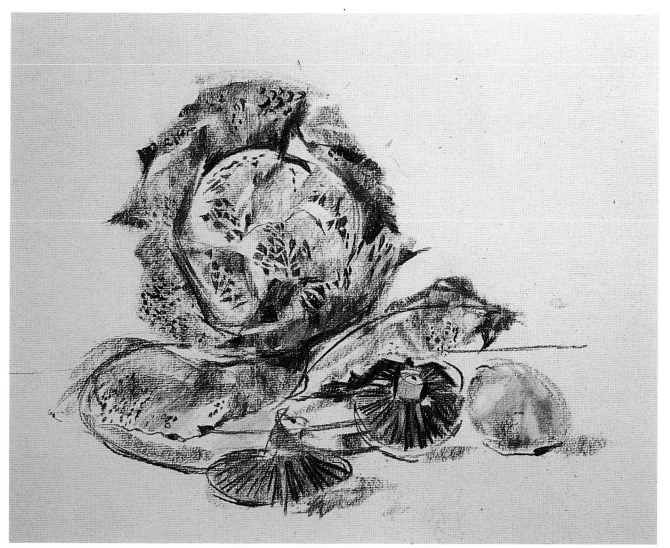

△ **11** *The final image is an accurate description of the subject and the charcoal gives it a rather pleasing quality. But if you have worked through a similar exercise yourself you will have a much better understanding of the way that tone describes forms.*

You will also have been surprised by the speed with which the image was realised, and also by the way something which at first appeared to be a random mess of tone suddenly came together and was read as what it was – it's like magic.

PROJECTS

CYCLAMEN

For this plant study the artist combines pencil line with watercolour wash. The cyclamen makes an eye-catching subject with its twirls of flowers – like a child's plastic windmill – in Schiaparelli shocking pink. The leaves too are dramatic – big, closely clustered and heart-shaped with dark and grey-green marbling around the margins.

Start by studying the subject carefully and then make a series of sketches in which you reduce leaves and flowers to their simplest components. Pick up the plant and look at the way the flowers are attached to their stems. Now look at the overall form – although the plant is complex in detail it makes a compact silhouette. When you start to draw the flowers, the negative shapes between them and the outline of the plant against the wall will help you draw accurately – see pages 30–31.

The artist used brilliant liquid watercolours – these are dye-based and very bright. The disadvantage is that they are fugitive and fade on exposure to light. Other liquid media include inks (which also tend to be fugitive) and liquid acrylics which are lightfast. You could also use pan or tube watercolour, or gouache.

△ **2** *The artist started with a pencil drawing which defined the shapes of the leaves and petals and indicated some of the areas of dark and mid-tones. He used a loose, flowing line which captured the swirling character of the plant. Notice that he has indicated some of the veining on the leaves, especially where these help to describe the leaves' convex curved surface.*

▽ **3** *Using a thin (rigger) watercolour brush he lays in a bright fuchsia pink for the petals – in places he has warmed the cool pink with touches of scarlet. In some areas he uses a diluted wash for a lighter tone – in others he leaves the white of the paper to stand for highlights. You can work freely within the confines of the drawing.*

△ **1** *The shocking-pink cyclamen demanded to be painted.*

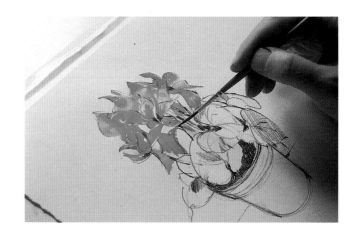

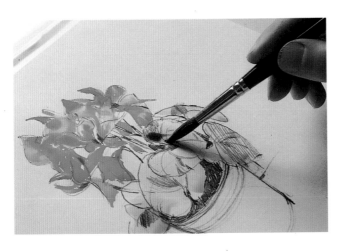

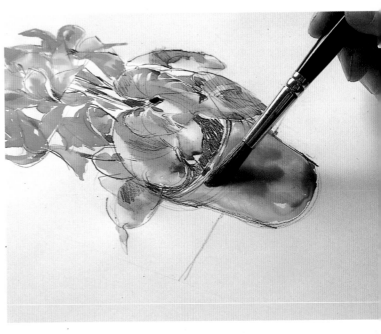

△ **4** *He lays in a dilute wash of sap green for the leaves and then touches in a cooler blue-green, working wet-in-wet to create subtly blended colour.*

△ **5** *The earth red of the plastic plant pot is laid in using orange, red and brown applied wet-in-wet.*

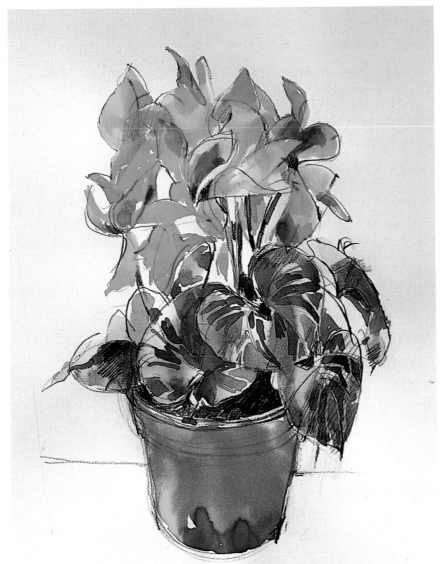

◁ **6** *A few strokes of dark green are applied to the leaves – to suggest the surface pattern and the veins. In the final image, the drawn lines show through the bright transparent watercolour and serve to hold the image together.*

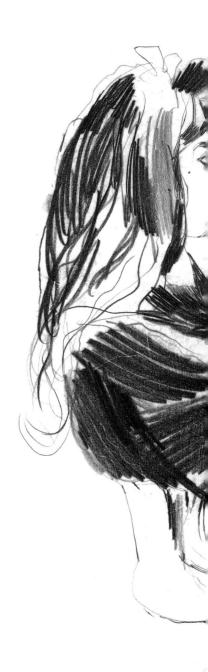

Drawing the figure

THE HUMAN FIGURE is a daunting subject though it really shouldn't be any different from any other. The problem is that we are an egocentric lot and apply different standards to drawings of ourselves than to any other subject. We have a good eye for the human form because we are constantly engaged with our fellow humans and so instinctively know when a drawing is wrong – though we may not know what is wrong.

The human figure is a complex structure so let's think about your own body. Underlying everything is the rigid skeleton. This gives the body rigidity and provides a fixing point for muscles and tendons. The bony skeleton is held together by layers of tendons, cartilage and muscle. These provide the tension and the power for movement. Over this there are layers of fat, thicker in some areas than others, and more evident in some individuals than others.

In this chapter I'll help you to look at the figure so that you can see it more clearly.

In this charming study by Albany
Wiseman, the artist has used a dark,
waxy EB pencil. He uses a fine,
sensitive outline for the woman's
profile and the graceful curves of her
arms. This contrasts with the
vigorous hatching and scribbling
used for her dress and her hair.

BASIC PROPORTIONS

The impact and usefulness of any representational drawing depends on the accuracy with which you reproduce angles, the slope of lines and the proportions between one element and another. There are several devices which can help you do this. Start by laying in a few lines which establish the large proportions of the subject, working lightly with lines which barely show. This will allow you to see how the drawing sits within the sheet. Now establish a fixed point from which you will work. In the front-view head on this page the centre line has been established and horizontal lines have been used to indicate the location of the eyes, the hairline, the base of the nose and the lips. At this stage you should stand back from your drawing and check the proportions. Generally you do this by eye but there is a simple way of checking the accuracy of your measurements.

To do this you hold your pencil vertically, with the pointed end down. Now extend your arm fully, close one eye and look at the object you wish to measure. Align the top of the pencil with a key point – say the top of the model's head – and slide your thumb down until it aligns with another

important point – say the chin of the model. Now you have captured a measurement that you can check against other measurements to ensure that proportions are correct. For example, the human head fits into the standing figure approximately 7½–8 times. That proportion varies from one person to another, but it is a good rule of thumb.

When starting a figure drawing you can very quickly establish this important measurement. By rotating the hand, using the wrist and arm as a pivot, you can compare vertical measurements with horizontal and oblique measurements. Use this technique at an early stage to check that the proportions of your basic drawing are right and at a later stage if something looks doubtful.

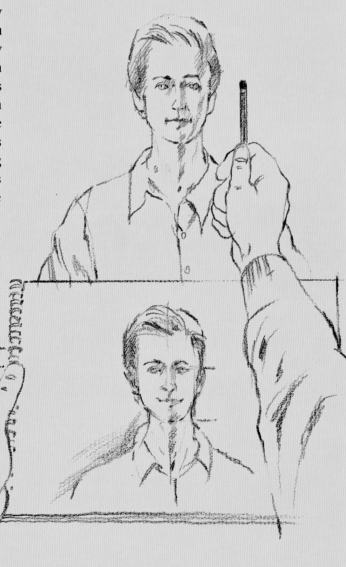

▷ *To check proportions, hold the pencil vertically with arm fully extended. One eye should be closed. Firstly, mark the base of the key measurement with your thumb. Now, still keeping your arm fully extended, move the pencil across to the measurement you want to check.*

▽ *A comparison between a face in profile and full on reinforces the fact that relationships remain the same. Notice that including the hair line, the eye-line is halfway between the top of the head and the chin – this may come* *as a surprise. The top of the ear is, in fact, level with the eyebrows and the nose and the forehead are about the same height as each other. Check these measurements for yourself.*

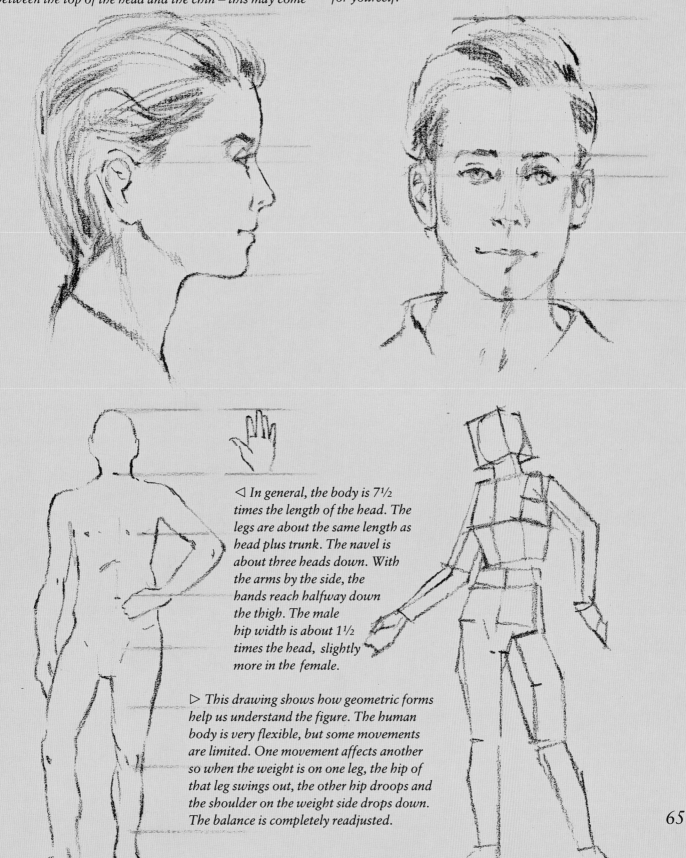

◁ *In general, the body is 7½ times the length of the head. The legs are about the same length as head plus trunk. The navel is about three heads down. With the arms by the side, the hands reach halfway down the thigh. The male hip width is about 1½ times the head, slightly more in the female.*

▷ *This drawing shows how geometric forms help us understand the figure. The human body is very flexible, but some movements are limited. One movement affects another so when the weight is on one leg, the hip of that leg swings out, the other hip droops and the shoulder on the weight side drops down. The balance is completely readjusted.*

TECHNIQUES

CONSTRUCTING THE FIGURE

A detailed knowledge of anatomy will give you more understanding of how the body works, but it is quite possible to produce accurate and expressive drawings using observation and simple measurements.

Human movement is dependent on flexibility. The human body changes shape as it moves, the compression of one area causing another to stretch and so on. Some joints are capable of a great deal of articulation – move your hands from the wrist, and your arms from the shoulder and you'll see that they are capable of a wide range of different movements. Move your foot and swing your leg from the knees and you'll see that these movements are more restricted.

Now stand up and move your torso from the waist – this gives you quite a limited range of movements. You should be particularly aware of the waist as its movements define many poses and gestures. A movement in one part of the body often has an impact on another part of the body. If, for example, you stand straight, balancing on both feet, your weight will be evenly distributed. Shift your weight to one foot and that hip and shoulder will

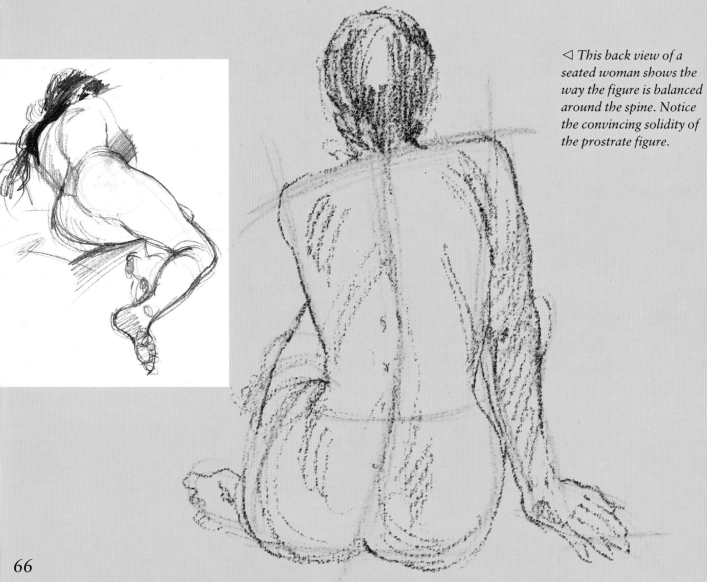

◁ *This back view of a seated woman shows the way the figure is balanced around the spine. Notice the convincing solidity of the prostrate figure.*

drop, and you'll notice that your other hip swings out. The centre of balance is now over the weight-bearing foot and your neck too will have shifted to that side. If you are drawing and find the pose confusing, adopt the position yourself. There is no better way of understanding what is happening.

Another useful aid to understanding is to think of the human figure as a doll made up of simple, geometric shapes like cubes and cylinders which are joined with elastic. This can be helpful when you are trying to visualise the way one section articulates against another.

There are a few points which are worth remembering. The neck doesn't sit on top of the shoulders, but is set slightly forwards of the sloping shoulders. The foot is a wedge shape – wider at the toes than

▷ Observe how, even when the figure is swaying, the neck remains over the centre of gravity. You can also see the ellipses of the torso and the foreshortened leg.

▽ The supine figure is turned, but you can sense the spine connecting the head, the torso and the limbs.

at the heel and is flat bottomed – on the outside edge the entire foot makes contact with the ground. The hand is a flat rectangle with fingers attached and a thumb at the outside. The head swivels on the neck – to find the limits of the movement try turning your own head. The head can bend backwards and forwards – again within limits. Once you start to think about these things you will find that you are more aware of your own body and its remarkable flexibility – and the limits of that flexibility. It is surprising how little notice we take of our own bodies in the normal course of events.

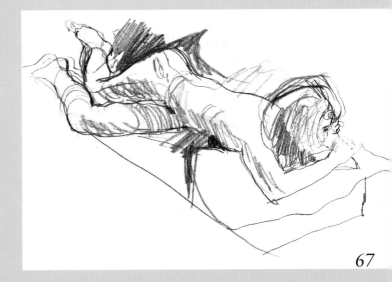

67

PROJECTS

KIM

For this, your first measured drawing you should draw 'sight size'. To understand this concept imagine that there is a sheet of glass between you and the subject. Better still imagine that you are looking at the model through a window. Now imagine that you can trace the image on the glass – with crayon or marker, for example.

In fact, try this exercise. Find an object in the room you are sitting in – a table and chair perhaps. Now close one eye, extend your arm and use your pencil to trace the outline of the tables and chair in the air. You will see that your 'air trace' is smaller than the objects actually are.

Now, hold your pencil up and take a measurement in the way we described on page 64. Align the top of the pencil with the table top and use your thumb to mark the length of the table leg – now transfer that dimension to the paper. If you continue with the drawing you will be drawing sight size. The drawing will be the same size as it would be if you traced it off on glass. Furthermore, if you move towards the object all the measurements will get bigger – so the final image will be bigger. If you move away the measurements get smaller, so the image will be smaller.

While we're making these observations I'll show you why we always say close one eye when you are in the process of measuring your subject accurately. Hold your pencil up against the chair leg and look at it with two eyes open, now close one eye, now close the other. Dramatic, isn't it? The object you are observing seems to move. I'm looking at the upright of an easel. With both eyes open the pencil is centred on the easel, if I close my right eye the upright appears on the left of my pencil, but if I close my left eye it appears on the right of the pencil.

Persuade someone to sit for you – or draw yourself in a mirror. Draw sight size and make lots of measurements so that your drawing is covered with 'ticks' that record them.

▽ **1** *For this study we selected a seated pose, which is more comfortable for the model. It does present a challenge in perspective as the model's knees project forwards and become distorted because they are foreshortened. Don't worry – simply draw what you see and when in doubt take measurements with your pencil.*

△ **2** *Here the artist uses his pencil to find an accurate measurement of Kim's head.*

▽ **3** *He transfers that measurement to the paper – at sight size.*

▷ **4** *Start by blocking in the broad outline of the figure. Work lightly, measuring and checking dimensions and relationships, taking nothing for granted. Use your pencil to measure the slope of her arms. Hold the pencil up, at arm's length, and lay it along the fall of her forearm – you can then transfer that slope to your paper. Don't concentrate on outline; other features like the folds of her clothing (around the arm, for example) give you a clue to the forms underneath. Look for the way the creases become ellipses around the upper arm.*

▷ **5** *With a sharp soft pencil add some details to the face. Use thick and thin lines to describe different sorts of edges. An emphatic line captures the thickness of the upper lid and also the darkness of the eyelashes. Fine lines describe the depth of the lid.*

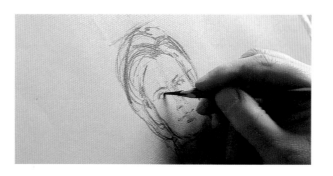

▷ **6** *Energetic, dark pencil lines capture the springiness of Kim's hair. Follow the flow of the hair and think of it as masses and locks with volume rather than as strands. Touches of dark tone under the chin, the lower lip and the nose give the head solidity. Hatched shading on the side of the face, nose and within the eye sockets implies the light falling on the face. The artist now applies a little colour using coloured pencils. They can be sharpened to a fine point and provide good, strong colour. Add the colour loosely so that the paper shows through: in that way the colour will mix in the eye to create a sparkling, lively effect. Notice also the way light tones tell on the tinted paper.*

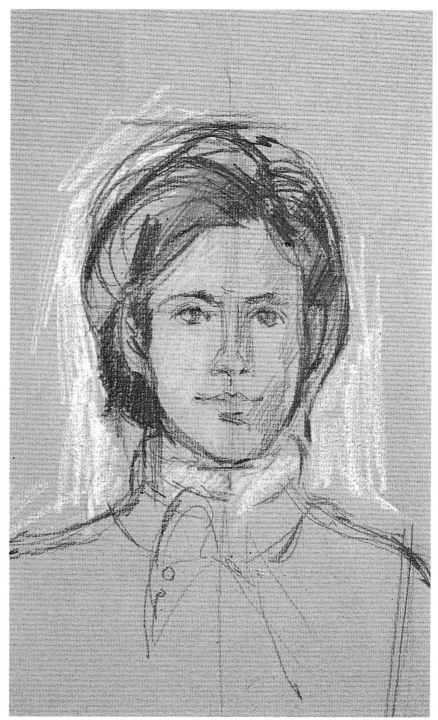

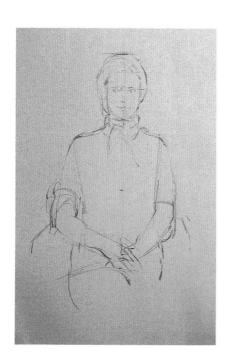

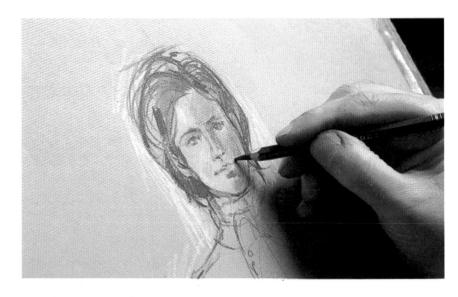

▷ 7 *The artist continues to add colour and tone, using a dark red for warm flesh tones in shadow and an earth yellow for warm tones where the flesh catches the light. And remember, don't focus on one area to the exclusion of the others. See the image as a whole and keep all of it going.*

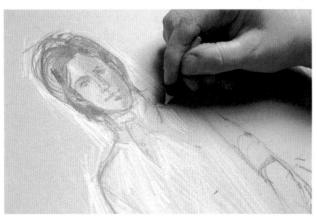

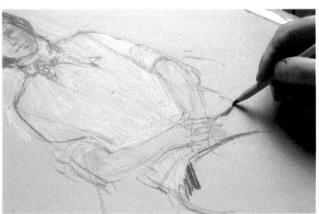

△ 8 *Using cool grey pencil, Albany scribbles in some colour for the pale blue of Kim's jumper. The warm buff colour of the paper emphasizes the blueness of the grey pencil and breathes warmth into the image.*

▷ 9 *The face – the focus of the study – is rendered more precisely than the rest of the figure. But it is not overworked. Notice the way the scribbled colour on the jumper suggests the character of a knitted fabric – and the way the pencil lines follow the folds around the arm.*

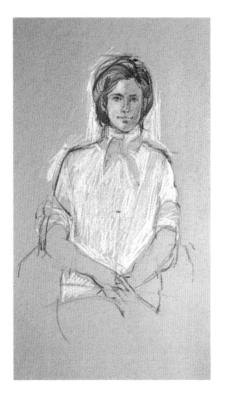

△ 10 *The artist uses the same pinks and ochres on the arms as he used for the flesh tones on the face and by keeping to a few colours he gives the image coherence. Here he adds some dark tones where the edge of the jersey lifts away from the figure. Little touches like this give some important visual clues – you don't have to elaborate them.*

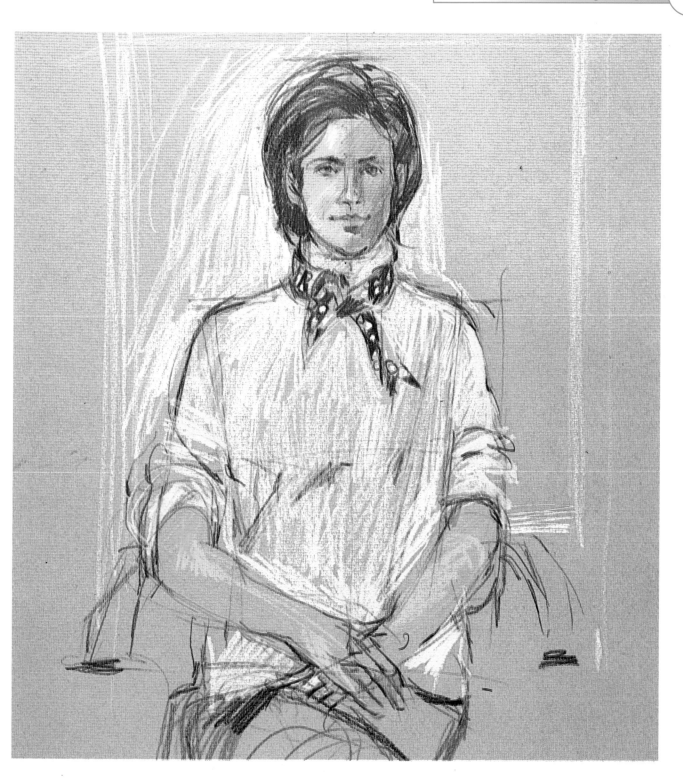

△ **11** *With dark pencil the artist adds some darker shadows between the fingers. By drawing the spaces in-between he allows the fingers to emerge. If you draw the fingers they are likely to appear as rather clumsy, sausage shapes. Notice also the way he has indicated the curve of the joints where the fingers change direction, and the way they have been treated as a unit rather than separate components. The legs are indicated with sparse but descriptive lines in blue pencil. Curving lines indicate the roundness of the thigh. Notice how short the thigh appears – about the same length as the head. It would be sensible to take measurements to check these dimensions as your assumptions are likely to be incorrect and you probably won't believe the evidence of your own eyes!*

DRAWING HEADS

Let's have another look at the head. Try and persuade someone – a friend or a member of the family – to sit for you. Draw them quickly, from as many angles as possible – full frontal, profile and three-quarter, with head bent and with head tilted up. Remember the basic proportions – we've already mentioned some of them. The eyes are about half-way between the chin and the top of the head, and are about one eye-width apart. The eyebrows are about even with the top of the ears.

The nose is about the same depth as the forehead. The lines of the eyebrows, nose, eyes and mouth tilt as the head is lifted or lowered. Imagine an egg with these lines traced on it – as the head is tipped forwards the curved line tips forward so that the edges of the eyes, brows and lips curve up. When the head is tipped up the curves of these features curve up further and the outer edges appear lower than the centres. Look at yourself in the mirror and you will see that this is true.

The skull is a bony structure with a few distinctive surface features. The eye sockets are recesses – the eyes are spheres that sit within these recesses, enclosed by the eyelids. You can feel the bony edge of your own eye socket with your fingers – you can also feel the protruding ball of your eye. Individuals vary in the amount of fat and skin they have around their eyes and it is this characteristic and minor differences of bone structure which give them their unique appearance.

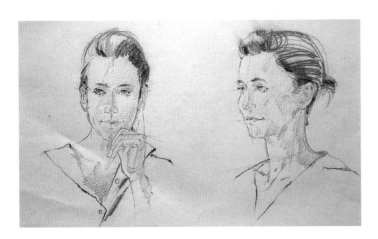

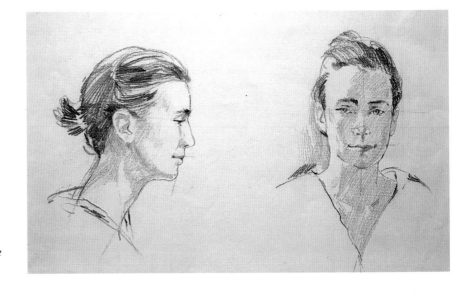

▷ ▷ *In these studies you can see the way the features relate to one another. The eyes are mid-way between the chin and the top of the head. The eyebrows align with the top of the ears and the nose is about the same depth as the forehead. Lines through these locations tilt as the head tilts – something which beginners often forget. Persuade a friend to sit and make as many drawings as you can. Start with full-frontal, profile and three-quarter views. Notice the way the relationships between the features appear to change as the head is tilted up and then down.*

△ ▷ *In these studies the head is shown full face, in profile and in three-quarter view. The full face view has a basic symmetry – try drawing it in different light conditions. You will find that the planes of the face are revealed by strong sidelight. The three-quarter view is asymmetrical and conforms to the rules of linear perspective. You will find that a line through the eyes and the mouth recedes to a vanishing point on the horizon. Again, strong light reveals the planes and facets which make up the rounded surface.*

There are also ridges on the surface – along the brows, the cheek bones, the nose and the chin. Run your hands over your face and you can feel them. These too vary from person to person – for example, some people have a gaunt appearance, obvious cheekbones and a large nose; others have smaller features, and more fat to mask the underlying structures.

The mouth is a remarkably mobile feature and difficult to draw convincingly. The trouble is that the mouth – and the eyes – are so important to the way we recognise and assess people that we tend to give them undue attention in our drawings. It is a common mistake to make the eyes too large and to over-emphasize the mouth. Often if a portrait looks a bit odd you can improve it by simply smudging the eyes and the mouth with your fingertip, so that they meld more successfully with the rest of the face. The bottom lip is usually lighter in tone than the upper lip because it is a plane which faces up and catches the light. There are occasions when this is not true – if, for example, the face is lit from below or is painted with dark lipstick. The open mouth is sometimes a problem. You may be tempted to draw each tooth – but usually we are aware only of a glimpse of a lighter tone. By putting in the darkness of the mouth aperture you will probably find you've done enough. In profile the upper lip juts over the lower lip and there's a recess under the lower lip.

The nose is the most architectural structure of the face and gives you a great deal of information about the tilt of the head. If you feel along your own nose you'll find that the end is very squashy. The tip of the nose varies a great deal from individual to individual – some are big and bulbous; others are neat and sharply defined. From the front the nose is mostly defined by shading and the shadow beneath the nose is an important clue to shape. The amount of the nostrils visible depends on the tilt of the head.

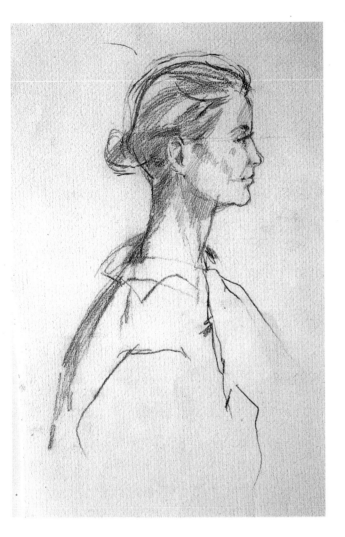

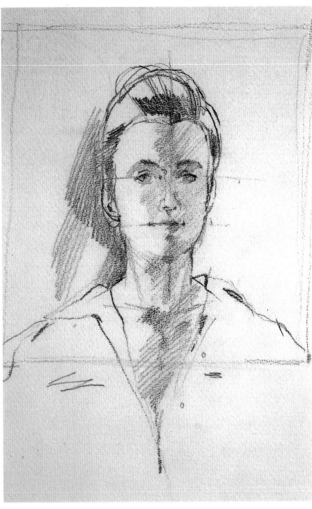

PROJECTS

KIM IN QUILL

A quill pen has a special, rather scratchy quality. The technique for cutting a quill pen is very simple – and hasn't changed since the Italian artist Cennino Cennini wrote his *'Il libro dell'Arte'* in fifteenth-century Florence. He recommends a goose quill. Start by cutting off the tip of the quill, using an oblique cut. Now measure about one inch from the tip of the quill and cut halfway through the quill using a scooping cut. Cut away to the tip. You should now have something that looks a bit like a crude dip pen. Next make a central slit in the 'nib' and refine the nib shape by cutting the sides to give you the point you want. The nib loses its shape quite quickly, but the joy of a quill is that you can recut it as necessary.

Albany worked fast with bold, fluid lines, enjoying the way the quill dragged and scratched the paper surface. The lines are darker where the pen has deposited more ink, lighter where he twisted the pen or it needed recharging.

He used a sepia brown ink, which is softer and less harsh than black – it is also a traditional colour for drawing ink and is particularly well suited for use with the quill pen.

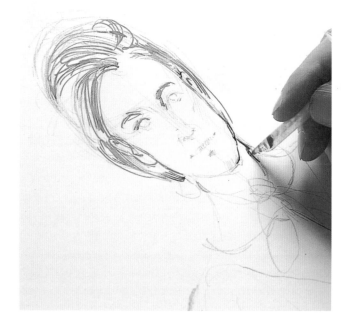

△ **2** *He started by indicating the broad outlines of the drawing in pencil. It is a good idea to check that you have got the proportions and the position on the paper correct before you commit yourself with an indelible medium like ink. Notice the way he has used fine lines to indicate the location of the eyes and the centre of the face. These construction lines can be erased.*

He then charged his pen with ink and used vigorous, curving lines to describe the brows, the side of the face and the hair.

▷ **1** *The artist, Albany Wiseman, posed the model, making sure that she was comfortable. He then seated himself about 5 feet (1.5m) away – near enough to see her clearly but far enough away to be able to include not just her head but also her torso and part of her legs. He works on cartridge paper on a drawing board.*

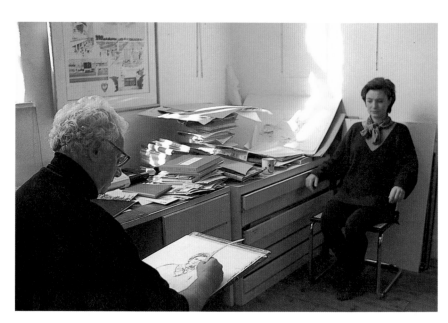

▷ **3** *The marks of the quill have a lovely crisp quality. Be careful to hold your hand away from areas of wet ink or you will smudge them.*

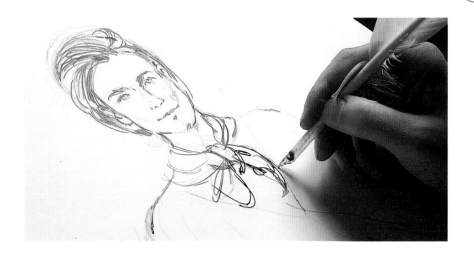

△ **4** *He continued working, building up forms, using a series of short lines to build up the outline, overdrawing lines where necessary and using repeated flowing lines to describe the folds of her jersey. Don't worry about getting a single, crisp outline — that would have a very static quality.*

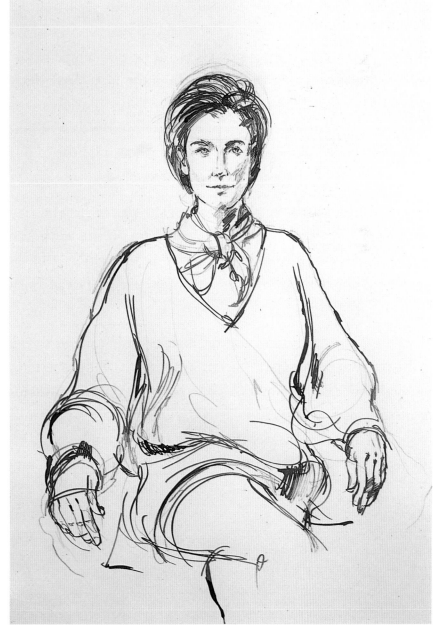

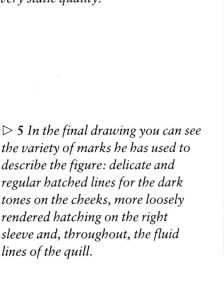

▷ **5** *In the final drawing you can see the variety of marks he has used to describe the figure: delicate and regular hatched lines for the dark tones on the cheeks, more loosely rendered hatching on the right sleeve and, throughout, the fluid lines of the quill.*

Landscape studies

●

Here we show a diverse selection of landscape studies by various artists. The dramatic study of a country church is by Gordon Bennet (top left), who also made the drawing of a churchyard beside it and the river scene (bottom right). For the church he used pen, brush and ink and combined detailed line drawing with areas of solid tone to create an image which is strong and graphic.

The churchyard scene was made on location using a worn fibre-tipped pen. This gave him a combination of dark lines and lighter, rather scratchy lines. For the riverside study he used a much finer fibre tip. This drawing was also made on location. Notice that he has recorded a fairly broad and bold description of the scene, but has also included details like the shadows under the bridge, the reflections in the water and an indication of the masonry on the bridge.

The three other drawings on the page are by Bill Taylor. In the study of tumbled-down buildings he has used tightly rendered and carefully blended pencil to describe the texture of weathered stone. The drawing is full of light. To create this he has paid close attention to the shifts of tone and in particular the shadows. The drawing beside it combines line and wash with great economy, while the study of farm buildings below a hill is line only.

T HE LANDSCAPE PRESENTS us with a challenging and constantly changing subject. In summer it provides a feast of glorious greens, blue skies, deep shadows and bright patches of sunlight. In winter the same vista will take on an entirely different aspect, and weather and time of day will also bring changes.

There are two ways to tackle landscape painting. The first is to work directly, making your painting on the spot. The other is to make drawings and sketches which can be developed later in the studio. In either case you need to be able to interpret and record what you see.

To tackle the landscape you need to be able to select your subject from a big vista, to sift and edit so that you have enough information to tell your story without confusing yourself or the viewer. In a landscape you are generally concerned with considerable distances. An understanding of perspective will help you describe spatial relationships and create a sense of recession.

●

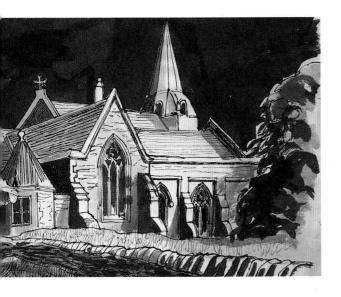

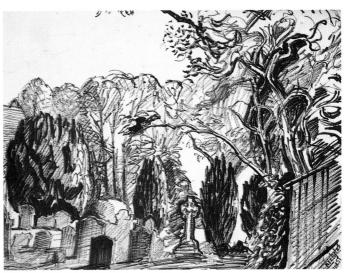

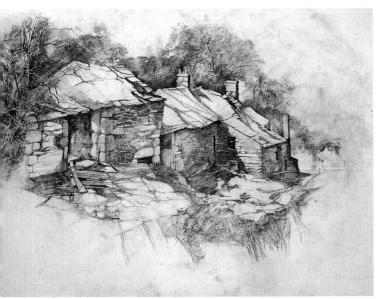

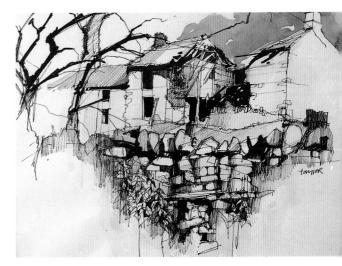

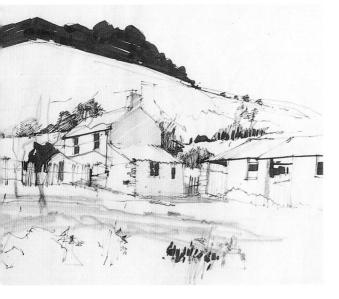

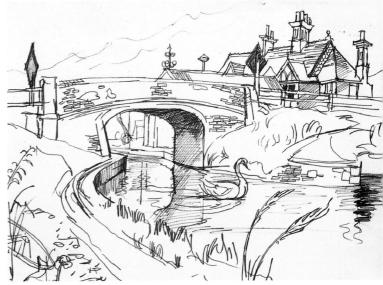

SKETCHBOOKS

A sketchbook has many functions. It is a visual diary, a record of family life, events - that have happened to you, places you've been and people you've seen. It is an archive, a source of inspiration and a volume of reference. What does a tree in winter look like? You need a window, a door, a person fishing – well, you should be able to go to your sketchbook and find one.

It is a place where ideas evolve and themes can be developed. You can make bold experiments and explore extravagant techniques knowing that, because it is labelled a 'sketch', you need not judge it as harshly as you would a 'finished' work.

A sketchbook is a place where you are allowed to make mistakes. Because the sheets of paper are bound together you are less inclined to throw away things you aren't happy with, so all the work – good and bad – is retained. This is important because, if you throw work away, you have nothing against which you can judge your progress. The review is a useful and informative process. Sometimes you look back and the flaws become instantly apparent. On other occasions you find value in something you disliked at the time.

Above all the sketchbook is a place to do exercises to improve your drawing skills – your ability to observe and to transcribe those observations on to a two-dimensional surface. Always do whatever you can to make sure that there are drawing materials to hand at the moment you feel

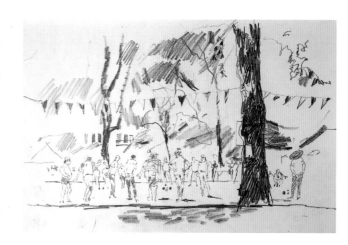

△ *Boules, but this time in Battersea Park in London.*

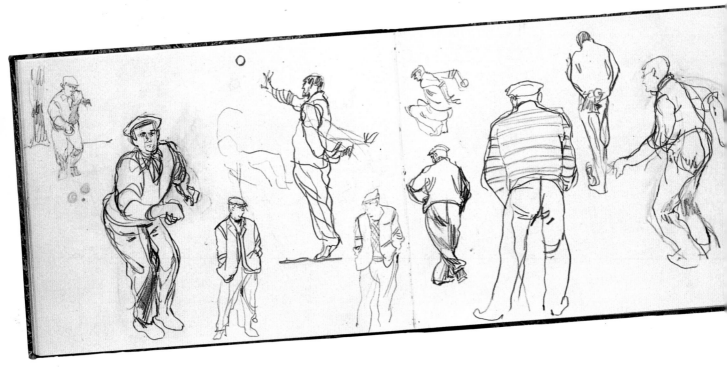

△ *People playing boules in France.*

inspired. If necessary have several sketchbooks – one in your briefcase or bag and one in the house at the point at which you most often come to rest. Take a sketchbook to the park or the beach and force yourself to make drawings of running figures, children playing football, dogs being exercised.

Sketchbooks are particularly useful when you are away from home because they are so portable. You can make drawings and watercolours which can be worked up into paintings when you return to your studio. You can make records of complete views and supplement them with details – gates, drystone walls, the texture of crumbling masonry, for example. Some people keep separate sketchbooks for different purposes – one for drawings of the children, for example, one for studies of animals, and one for holidays. Work out a system that suits you – but, whatever you do, get used to putting pencil or pen to paper every day.

All the sketches featured on this page are by Albany Wiseman.

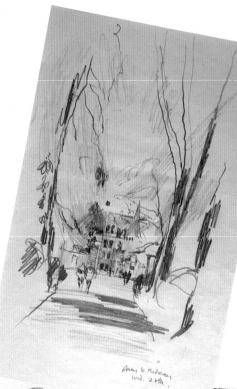

▷ *This delightful pencil sketch enlivened with colour pencil was made on location in France. Albany has managed to record a great deal of information about the people, the place and the quality of the light.*

◁ *A quick landscape sketch; notice the economy with which the artist has noted the areas of sunlight and shadow.*

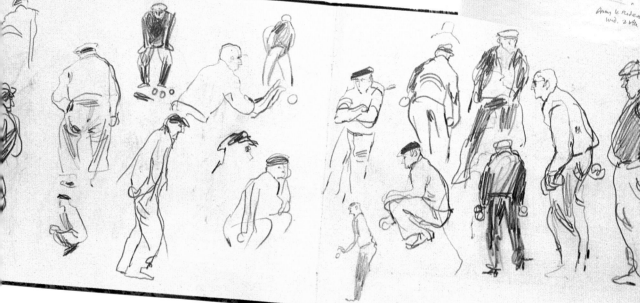

GRIDDING UP

If you have made a sketch and want to use it as the basis of a painting you will have to copy it from your sketchbook on to a new support. Often you may want to make it larger. The simplest way of enlarging something is to use a photocopier but that has its limitations – you can only copy on to paper and you can only enlarge in specified increments.

Gridding up is a simple, if somewhat time consuming, process. Basically you lay a grid of squares over your drawing – rather like the grid in an atlas or on a road map. This grid may be drawn directly on to the drawing as we have done here, or if you don't want to make marks on the drawing,

▽ **1** *The original sketch with a grid of squares drawn over it.*

you can draw up a grid on a sheet of acetate and lay it over the drawing.

To draw the grid you will need a T-square or a set square to ensure that you start with accurate right angles and keep all the ruled lines parallel to one another. Establish your first horizontal ensuring that it is parallel to any natural horizontals in the drawing – the horizon or a roof line seen face on. Decide what size mesh is going to give you the detail you require when transferring the drawing. Don't make the grid too small or you will confuse yourself and obscure the drawing.

Be sensible – if you are gridding up on to a larger scale you will require more detailed information than if you are reducing the drawing. Measure and mark the intervals on the horizontal. Establish a vertical – make sure it is at right angles to the horizontal and mark the same intervals along that. Now, using the T-square or a large set square, draw up the grid.

Now you need to grid up the support on to which the image is to be transferred. It must be the same proportions as the original. Decide how big you

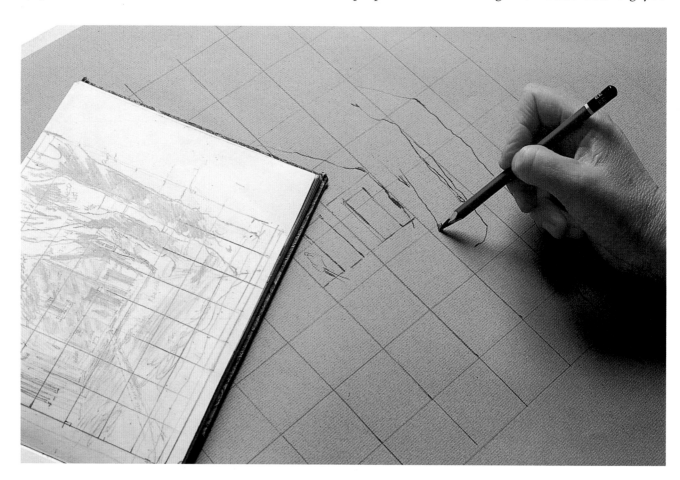

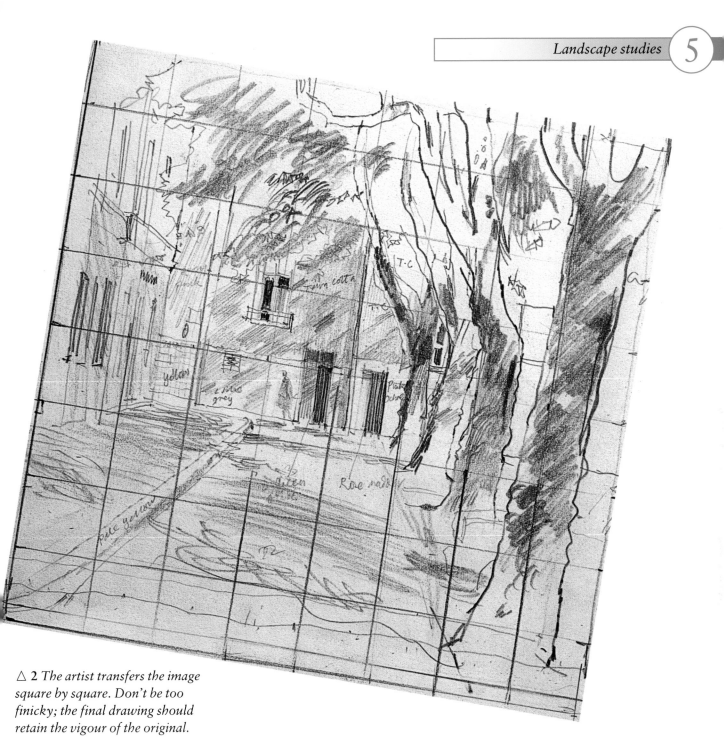

△ **2** *The artist transfers the image square by square. Don't be too finicky; the final drawing should retain the vigour of the original.*

want the new drawing to be. Say you want it twice as big, then the square of the grid will be twice as big. So if the original consisted of 10 × 15 1-inch (2.5cm) squares, the final support should be divided into 10 × 15 2-inch (5cm) squares.

The problem is to locate yourself on each drawing. A system of numbering co-ordinates used on street maps will help. Number the squares across the top of both grids (in our example 1–15), and label the squares down the vertical alphabetically. Then every square on your grid will have a unique designation and you will be able to locate, say,

square b-10 on both original and copy very quickly.

To make the copy simply find a key element of the original drawing – a strong diagonal or a strong shape like the apex of a roof and plot it in on the new copy. Work carefully but freely – you want the final drawing to capture the energy of the original. If you are too finickity the final drawing will look mechanical. In most instances once you've got the main features down you can transfer the details by eye. In fact you might want to make a few changes as you go anyway.

TECHNIQUES

ATMOSPHERIC PERSPECTIVE

Atmospheric or aerial perspective is a compositional device which allows you to create a sense of space when there are few linear clues. It mimics the way the appearance of things is modified by distance and the intervening veil of the atmosphere. To create a sense of space in a painting or drawing you need to be aware of the following contrasts, heightening them in the foreground and minimising them in the distance.

Contrasts of colour temperature Warm colours like reds and red browns are said to advance, while cool colours like blue appear to recede. Use blues and blue-greys in the distance and warm colours in the foreground. If a painting feels flat, you can increase the sense of space by introducing warm colours in the foreground and cooler colour in the background. Scarlet poppies in the foreground will appear cooler and bluer as they recede towards the horizon. The landscape will appear bluer as the distance from the viewer increases, so that hills on

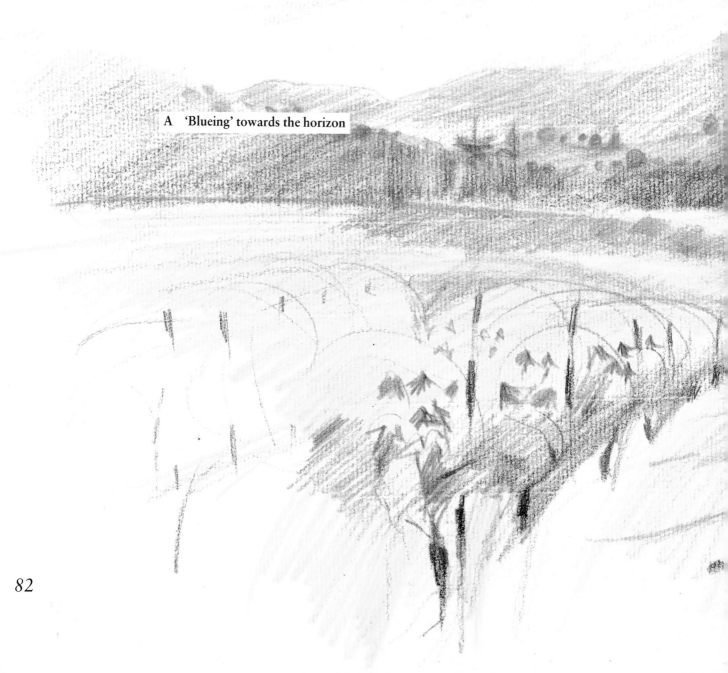

A 'Blueing' towards the horizon

the horizon will appear to be a pale blue or sometimes a dark violet blue – even though they are clothed with forests or heather.

Contrasts of detail The details of a tree or vegetation in the foreground will be seen clearly, with crisp edges. This is partly because we can see things close to most clearly but also because the atmosphere intervenes and blues objects in the distance. By adding a few crisp details in the foreground and simply smudging those in the background with your fingers you can very simply establish a sense of recession.

Contrasts of colour Colour is also changed by distance. Look at a tree close to you and you will be able to distinguish several distinct shades of green.

Now look at a clump of trees in the middle distance; they will be paler and bluer. Hills seen as a long way off on the horizon will look distinctly blue.

Contrasts of tone Tone is one of the ways in which we define form. In bright light an object close to will break down into lights and darks; in the distance the same thing happens but the contrast between the lights and darks decreases, so that forms appear less distinct.

Contrasts of texture If you look at the grass at your feet you can distinguish individual blades – the surface of a meadow a field away will have a definite texture but you won't be able to see individual grasses. A grassy field in the distance will appear green and textureless.

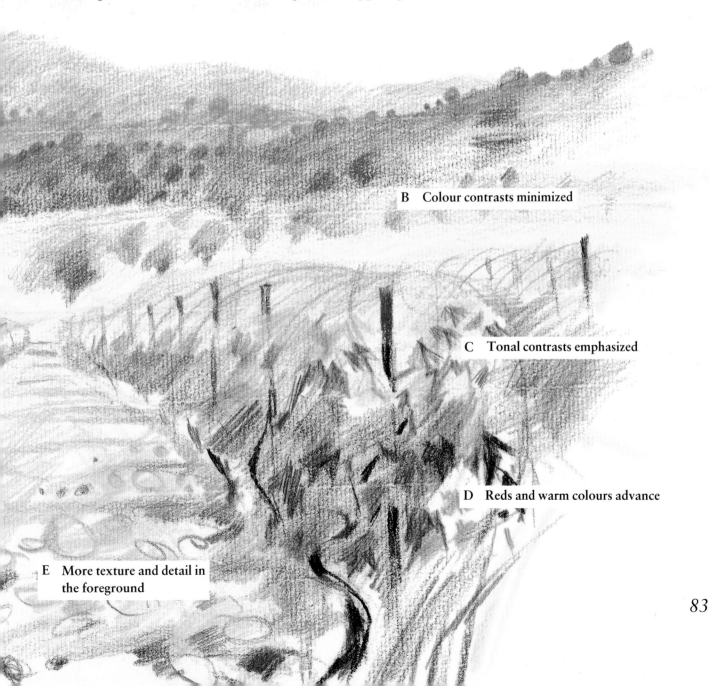

B Colour contrasts minimized

C Tonal contrasts emphasized

D Reds and warm colours advance

E More texture and detail in the foreground

PROJECTS

VIEW FROM THE CONSERVATORY

The fact that distance affects the appearance of things was noted and commented upon by Aristotle. It can be seen in the paintings on the walls of Pompeii and was described by Ptolemy (2nd century AD) who said that when painters of architectural scenes wish to show colours of things seen at a distance they employ 'veiling airs'.

We see this 'veiling' because the atmosphere which envelops the world isn't a vacuum, but consists of gases, moisture and tiny particles of different materials. So even though the atmosphere is generally transparent it has an impact on light travelling through it. Light is absorbed and scattered as it collides with particles in the atmosphere, creating effects which vary with the weather and the time of day.

This landscape study was made on a day in early spring when the weather couldn't make up its mind what to do. One minute shafts of brilliant sunlight illuminated the scene, the next the sun was hidden behind threatening clouds. The artist decided to work from the shelter and comfort of a conservatory which afforded this magnificent view.

The light changed constantly. One minute we could see a range of low, pale blue hills vaguely defined against the horizon, then suddenly some high peaks would emerge behind them and the entire range would become intensely blue and more crisply defined, changing the whole aspect of the scene. But it was a good example of the practical problems you have to contend with when describing the landscape. You simply have to record what you see and where necessary rely on your memory.

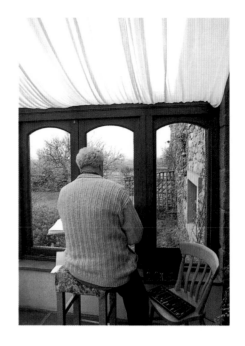

△ **1** *Driven indoors by the vagaries of the weather, the artist decided to draw the view from the window.*

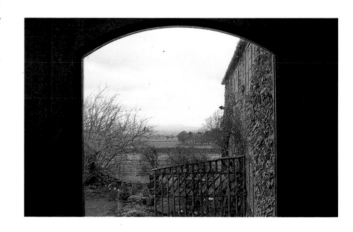

△ **2** *This is more or less the view that he saw. In this picture you can see the mountains just beginning to emerge; in the previous picture they are veiled in mist. Notice, too, that the distant views are indeed blue and indistinct.*

▷ **3** *In this sketch the artist mapped out the composition.*

▽ **4** *Here he explored the over-lapping planes of the landscape, receding into the distance.*

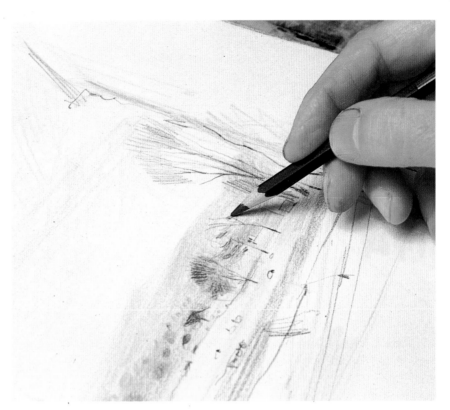

▷ **5** *He laid out the main elements of the composition in pencil, and then started to block in colours using colour pencils. He worked lightly, giving a mere indication of the colours.*

▷ **6** *Already the drawing has a sense of recession. The eye is led along the wall on the right to the cluster of farm buildings and trees which are a focus of the image. The blue, lightly indicated hills sit well back into the distance on the picture plane.*

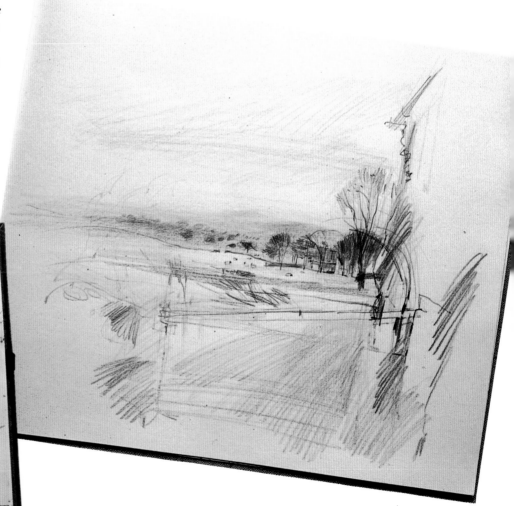

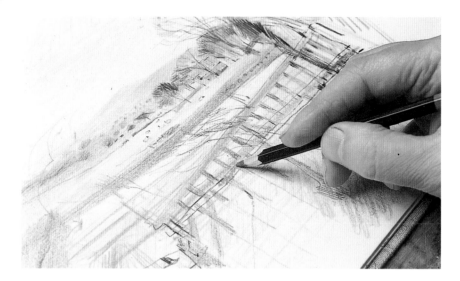

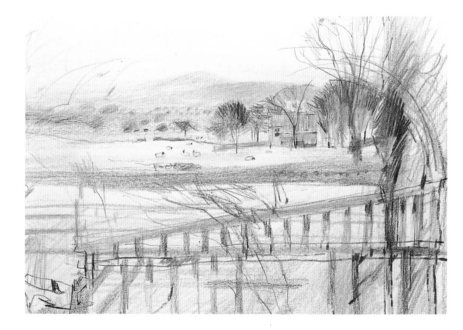

▷ **10** *The foreground has been further refined and now has a pleasing decorative quality. Notice the difference between the marks used to describe the tree on the left – a series of twisted, wiry curves – and those of the shrubs in the immediate foreground. The artist has found just the right varieties of line to capture the character of the different plant forms.*

△ **7** *Now the artist begins to develop the foreground, adding the details of railings and vegetation which draw the eye to this area. He uses primarily warm, earth colours which advance on to the picture plane, while the cool blues recede.*

▷ **8** *This detail shows the delicacy with which the coloured pencil has been applied, so that it forms a veil of transparent colour. You can also see the variety of vigorous linear marks which are used to describe different elements: solid colour for architectural features like the wooden paling, and delicate, twitchy marks which describe the winter-bare twigs and shrubs.*

▷ **9** *More detail is added in the foreground. By adding texture and colour in this area he makes the drawing more descriptive and it is easier to identify and understand what we are looking at. It also increases the sense of recession by emphasizing the difference in detail between this area and the distant horizon. This is sometimes called a texture gradient because you see more texture in the foreground than in the distance.*

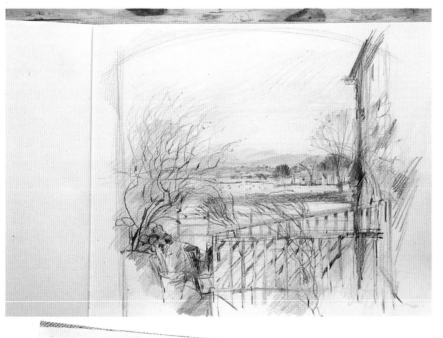

▽ **11** *As a finishing touch the artist decided to emphasize the arch of the window – creating a natural frame for the image. This works well, creating a sense of a view glimpsed rather than steadily contemplated. It also illustrates the way an image evolves and gradually takes on a life of its own. Each drawing is a voyage of discovery and when you start you are never quite sure what you will find along the way, or where you will finish.*

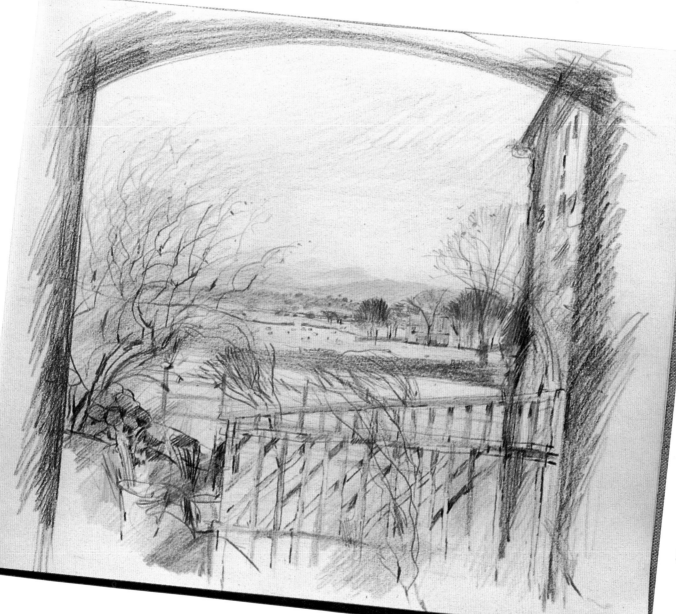

TECHNIQUES

LINEAR PERSPECTIVE

Linear perspective is one of the best known and least understood pictorial clues to depth. The system allows you to create a convincing illusion of three-dimensional reality on a flat surface such as a sheet of paper. The relative position of the objects and their relative size will appear to the eye just as they appear to the eye in real life.

Unfortunately, the more you try and explain linear perspective the more difficult it sounds. Basically objects such as figures which you know to be the same size appear smaller the further away they are. All parallel lines converge at a vanishing point on the horizon. Lines below a high horizon line slant upwards. Lines above a low horizon line slant downwards.

The eye-level is the height of your eyes from the ground as you view the scene. If you are tall your eye-level will be higher than if you are short, and a child's eye-level will be lower than an adult's. Eye-level defines how far you can see – if you are taller or higher up, for example, if you are standing on rising ground, you can see farther than if you are shorter, sitting down or crouching.

The horizon line is the line at which the sky meets, or appears to meet, the ground. The eye-level directly affects the horizon line – if you are tall or high up you will be able to see farther so the horizon will appear to be farther away. If you are short or crouching down you won't see so far into the distance and the horizon will therefore appear to be nearer to you. The horizon line coincides with the eye-level.

The vanishing point is the point on the horizon line (eye-level) at which lines representing actual parallels seem to converge.

In most instances you can draw accurately by direct observation – the only time a knowledge of perspective comes in handy is when something looks wrong and you can't decide what it is in order to be able to correct it.

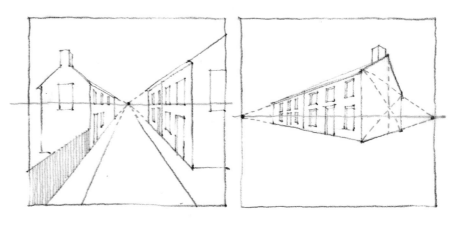

▷ *One of the most striking examples of linear perspective is the way parallel lines that recede into the distance appear to converge at a point on the horizon (the vanishing point). Here you can see that all the parallel lines converge at the vanishing point. Lines below a high horizon line slant upwards. Lines above a low horizon line slant downwards. This is an example of single-point perspective so there is only one vanishing point.*

▷△ *In two-point perspective there are two vanishing points. Here you are standing at the corner of a building so that two sides are going away from you. The baseline and roofline of each side will converge on two different vanishing points on the same horizon line (eye-level).*

▷ *If you stand in the centre of a room which has parallel and vertical walls, the vanishing point will lie at your eye-level in the centre of the opposite wall. The lines made by the side walls will converge to that point. Here the viewer has moved left so the vanishing point has moved to one side.*

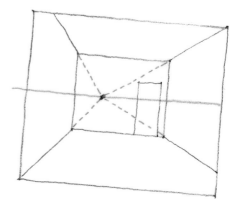

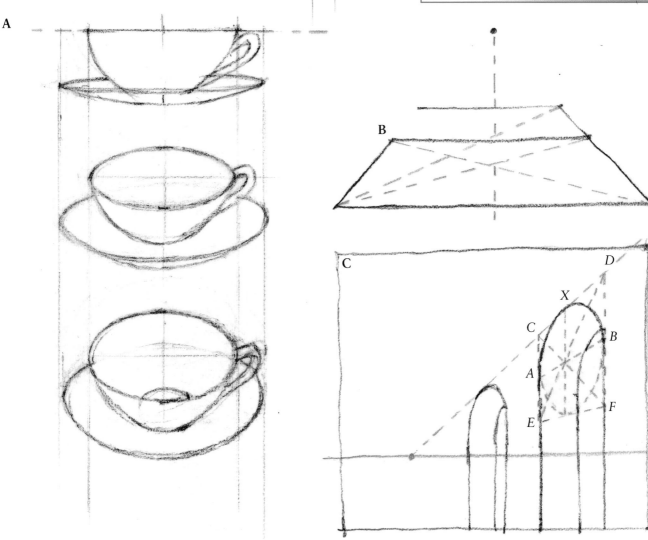

A *Circles seen in perspective become ellipses. To construct an ellipse you draw a square in perspective (above left) and then draw an ellipse within it. The centrelines of the square indicate the point at which the ellipse should touch the square. But it takes practice to get a smooth curve – it should just kiss the side of the square. Avoid an ellipse with pointed or blunt ends. With practice you will be able to draw them freehand with accuracy.*

B *Drawing a tiled floor in perspective looks difficult – but using our technique it's easy (right above). Start by establishing the width of the first row of squares. Now extend the sides of the square*

to the vanishing point. Find the centre of the square by drawing diagonals. Extend a line through this point to the horizon. Now drop a line from the corner of the square, through the point at which the centreline bisects the far side. The point at which this line intersects the orthogonal (the perspective line) gives you the depth of the next square. Repeat for the succeeding rows of tiles.

C *The technique for making the square in perspective can be used to establish the location of piers, pillars or fence posts disappearing into the distance (right below). A regularly curved arch is generally based on a semicircle. By observation, find the*

point at which the first arch springs from the vertical: (A) (B). Extend the vertical lines from A and B towards C and D. Drop diagonals from C to F and from D to E, giving a square in perspective: CDFE. A vertical line through the intersection of CF and DE gives the apex of the arch. Now draw an ellipse within this square, keeping the curves smooth. To provide the far edge of the arch, draw a line parallel to AX of the arch, extending it to the baseline. Extend CD and AB and EF to the point at which they meet on the horizon. This will establish the vanishing point and any further arches will align along these lines.

PROJECTS

MEASURING THE LANDSCAPE

This landscape drawing was made in spring in Cumbria in northern England. As you can see from the photograph, it is a potentially confusing subject with a mass of vegetation and trees framing distant views. To make sense of the landscape you must be prepared to simplify and edit what you see. Spend some time contemplating the view and decide which are the most important features. Try and remember what it was that first attracted your attention and try and capture that in your drawing. This was a lovely location with plenty of subjects for the artist. Albany didn't draw the first view he found but looked until he found one that was particularly interesting. This particular scene had strong compositional qualities. The stream provided an obvious focal point, leading the eye across the image and into the distance with a sinuous, curving line. The tree and the sapling on the other bank together form an arch which frames the stream and the distant landscape – a device which again leads the eye into the drawing.

Having selected your subject, you should frame it using either a viewfinder or your fingers. This will help you to decide on a landscape or portrait format and to establish the limits of your picture area. If you have used a camera with a zoom lens you will know just how different a wide-angle image is from a close-up of the same shot. Albany has chosen a viewpoint which corresponds more or less with his natural field of vision – and by vignetting the image he suggests the way our focus peters out at the edges.

It was a chilly day so Albany worked quickly, using colour pencil to scribble in a suggestion of the colour relationships.

△ **1** *The artist is working from the subject. The stream was in the grounds of the house he was staying in. He borrowed a chair: you might as well be comfortable if you are working out of doors – you will tire less quickly and are more likely to spend time on the drawing.*

▷ △ **2** *Here he uses his pencil to take measurements; notice that one eye is closed.*

▷ ▷ △ **3** *Here the pencil is used to check an angle. In both cases the arm is fully extended.*

▷ **4** *The final image captures the beauty of the place. It is accurately drawn, but the artist has not drawn every twig and every boulder. He has drawn some and merely suggested others. Nevertheless, he captures the turbulence of the shallow stream as the water swirls and eddies around the stones which litter the riverbed. He uses very little colour – just a suggestion here and there to act as an* aide memoire *should he wish to develop this as a painting at a later date.*

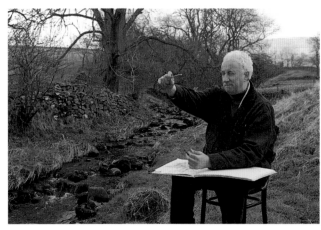

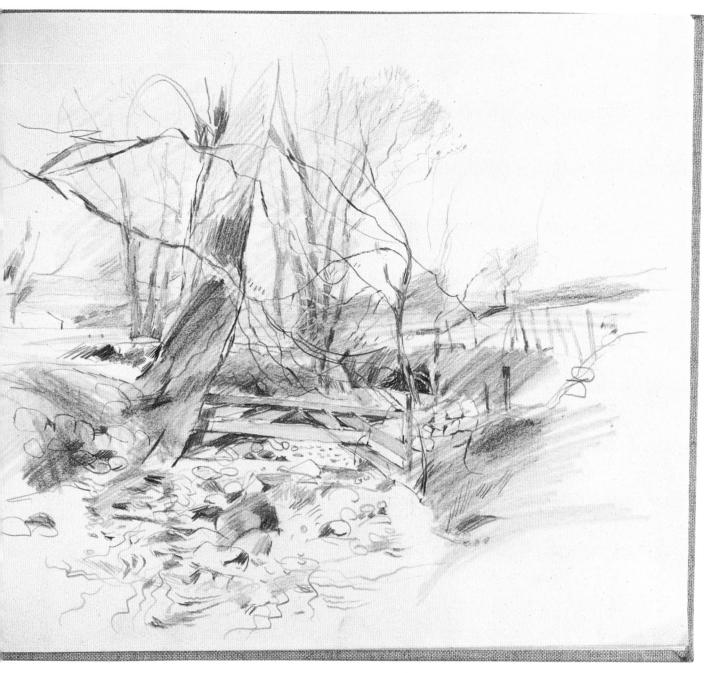

PROJECTS

KIRKLAND

We persuaded Albany to work out of doors on a chilly day in May. The subject was a cluster of stone houses along a country lane. To draw the buildings correctly the artist applied the principles of linear perspective discussed on page 88. He also used some simple devices to help him select, edit and decide what to emphasise.

The first device is called a viewfinder – because it helps you to find a suitable view. It is a frame made from card. You look through the window and scan the view to frame and isolate a subject. This is particularly useful in landscape drawing where there are so many possibilities. Albany used a viewfinder made from two L-shaped pieces of card clipped together to make a rectangular frame. This allows you to experiment with different formats. You can also use the viewfinder to try different compositions and establish how the image will fit on to the rectangle of the support. A viewfinder is simple to make, but if you haven't got one use your fingers to make a frame.

If you hold the viewfinder close to your eye you will frame a wide-angled vista – move it away and you will frame a smaller area.

Another useful device is the card scissors illustrated on this page. You will need two pieces of card – each approximately 6 × 1in (15 × 2.5cm). Punch a hole through one end and insert something that will allow them to pivot. I found a plastic popper for closing padded envelopes, but a piece of wire would do. You can use the scissors to check the angle between the top of a wall and a vertical, seen in perspective.

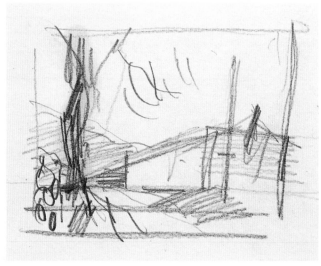

△ 2 *He used a pair of L-shaped brackets to make a viewfinder and looked through this to see how he should tackle the composition.*

△ 1 *The subject was a cluster of stone buildings along a country road. Albany walked along and decided to position himself at a point where the sweep of the lane led the eye up towards the buildings.*

△ 3 *He started by making a couple of quick, rough compositional sketches to see how the subject would fit on the page and which arrangement would give him the most effective image. On one he has cropped in close to the buildings; in the second there is a big sweep of road*

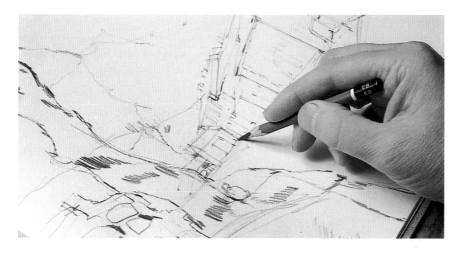

◁ **4** *Working with a soft pencil (EB), he lays in the broad outlines of the subject in light pencil lines. He uses a wide variety of pencil lines throughout the drawing: lighter for objects which are further away, darker and more emphatic for objects closer to the viewer.*

◁ **5** *Here he uses his 'scissors' to check some important angles. The telegraph pole provides a convenient vertical against which to measure the slope of walls and roofs. In time you will get better at making these assessments, but it is a good idea to check them constantly at the beginning. You will be surprised how often your assumptions are incorrect at first.*

▽ **6** *The drawing is broadly established. Notice how the verticals of the tree and the telegraph pole counteract the diagonal emphasis of the buildings and the way they lead the eye into and around the drawing.*

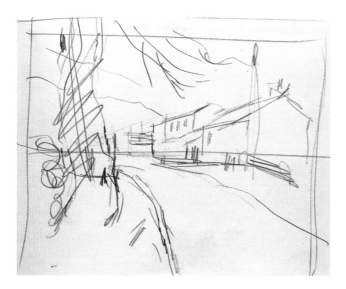

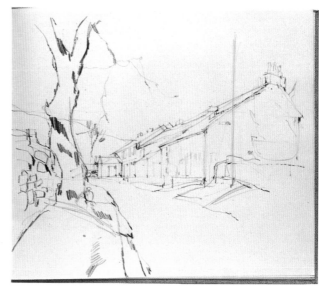

to lead the eye in. He has marked his eye-level on both drawings and this is important because it is the line to which all the orthogonals (perspective lines) will vanish. The eye-level is low because he is sitting down and the buildings are on rising ground.

▷ 7 *At this point the artist decided the drawing would be more effective with more foreground, so he added a piece of paper to extend the drawing to include more of the road. If you look back to the previous page you'll find that these proportions are close to the second of the original thumbnails. If a composition is wrong, or can be improved, correct it. And don't be precious about your drawings – the galleries of the world are full of examples of paintings and drawings which have been 'fixed' by adding on a bit, so you are in good company.*

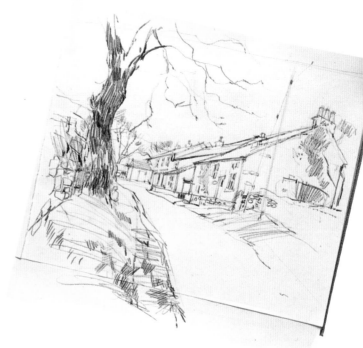

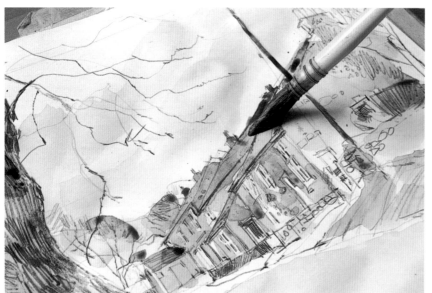

◁ 8 *Albany continued to work up the drawing, constantly checking it against the subject, making minor adjustments and keeping the whole thing going without allowing it to become overworked.*

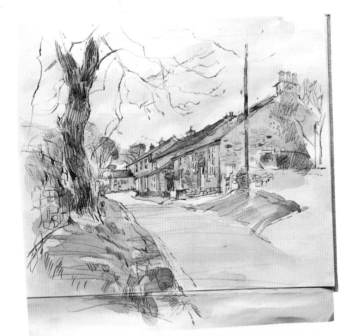

◁ 9 *He laid on a wash of colour, using watercolour and a limited range of colours. The final image is effective and pleasing.*

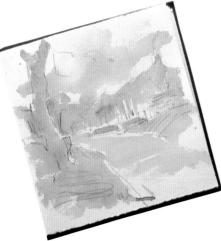

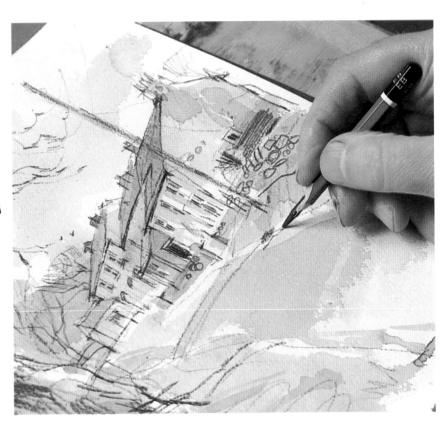

△ **10** *He then decided to have another stab at the same subject, working very fast and using the knowledge he had gained from the first drawing. He made a few pencil marks and then laid in broad areas of colour using thin washes applied wet-in-wet.*

△ **11** *When the watercolour was dry he started to work over it in pencil, working fast and with concentration.*

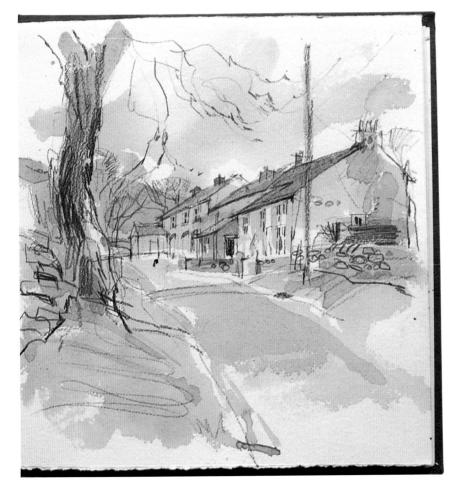

◁ **12** *It is interesting to compare this with the first drawing. In the first instance he applied wash over line; here he applied line over a wash. This one has much more spontaneity, but it could not have been achieved without the focused concentration of the first drawing. So don't think once you've drawn or painted a scene that that is the end of it. You can return to the same scene time and time again, finding different aspects every time. You can choose a slightly different view, or you may find that the season, weather or light will have entirely changed the appearance of the scene. Alternatively, you can try a new medium to see what happens.*

95

INDEX